Pocket Guide to

# Color
# Reproduction

## Communication & Control

**3.1 Edition**

**Miles Southworth**
and
**Donna Southworth**

Graphic Arts Publishing Inc.
Livonia, NY 14487-9716

D1300512

Printed in the United States of America
ISBN 0-933600-09-7

Printing history
First edition 1979
Reprinted 1980, 1983, 1985
Second edition 1987
Reprinted 1989
Third edition 1994
Revision 3.1 1995

**Credits**

Printed by Cohber Press, Rochester, NY
Bound by Riverside Group, Rochester, NY (*Otabind lay-flat binding method*)
Original cover design by Jennifer Dossin
Photography by Adam Dawson, Sandra Jackson, Suzi Romanik and Miles Southworth
Production assistance by Andrew Chen, Andrea Clough, and Derek Torry

Dedicated to our grandchildren

Erin Kathryn Jackson
and
Blake Miles Wetherington

# TABLE OF CONTENTS

MAKING COLOR SEPARATIONS

# INTRODUCTION

The use of color in printing increases daily. A higher percentage of printing is being done with the four-color process. The reasons are that printing color does not significantly increase costs, half the expense of a printed job is the paper, and color definitely has a favorable impact on customers. With technological developments linked to the desktop environment, the production costs for color separations and color pages have decreased dramatically. Once the color prepress function was in the domain of the printer or trade shop. Now it is in the creator or publisher's hands.

With knowledge about today's technology, it is possible for anyone to produce good quality color. However, many pitfalls plague the color reproduction process. If you do not understand the color separation and printing processes, then you will probably achieve poor quality color reproductions. Knowing the problem areas, and how to avoid them, will help you, the reader, produce good-looking printed color reproductions.

This book takes the reader through each production step from the original scene to the finished color reproduction. Each step is described in detail. By understanding what is expected, comprehending the process and knowing the variables to control, the reader will be able to communicate expectations and achieve the color quality desired.

**ADDITIONAL PUBLICATIONS
BY THESE AUTHORS**

*Color Separation on the Desktop*
Miles Southworth
Donna Southworth

*Color Separation Techniques, 3rd edition*
Miles Southworth

*Ink on Paper*
a monthly newsletter about imaging technology and business strategies
Miles and Donna Southworth
Frank and Patty Cost

*Pocket Guide to Color Reproduction, Third edition*
Miles Southworth

*Quality and Productivity in the Graphic Arts*
Miles Southworth
Donna Southworth
with chapters by Eisner, Killmon,
Layne, Marathe and Rebsamen

*How to Implement Total Quality Management*
Miles Southworth
Donna Southworth

*The Quality Control Scanner,*
1981 through 1994, a monthly newsletter about
color reproduction and quality control
Miles Southworth, Co-editor
Donna Southworth, Co-editor

*The Color Resource Complete Color Glossary*
Miles Southworth
Thad McIlroy
Donna Southworth

# GOOD COLOR—WHAT IS IT?

**What's necessary for good, clean color reproduction?**

The difference between a good color reproduction and a poor color reproduction is usually the result of:

- the color scanner chosen by the operator,
- the proper scanner or desktop computer setup for the printing parameters,
- the original's image and emulsion characteristics, and
- the scanner operator's image adjustment for a good visual reproduction.

Learn what is needed and you can always make good color reproductions. Keep in mind the following phrase:

*Clean and bright is always right;*
*Dull and gray is not the way.*
*A pretty sight that will delight,*
*The client will pay without delay.*

**What customers expect color reproductions to look like**

People count on good printed color reproductions to have correct contrast and color balance. They want the colors to be bright, clean and saturated. The picture should appear clear, sharp, and focused with the detail showing. People also expect memory colors to be accurate. *Memory colors* are blue sky, green grass, red apples, human skin, and items, such as fruits and vegetables, that people easily remember.

## What customers don't want to see

No one wants to think that they are looking at a picture through a dirty screen door or window glass. The picture should not appear flat without contrast. Deep, saturated colors should not appear pale or washed out. People in the picture should not appear ashen or sunburned. Caucasians should be tan and slightly warm; African Americans should be a warm, even brown. Nothing in the picture should have a *color cast* that makes it appear too blue, green or red.

Fuzzy, out of focus or out of register reproduced images are undesirable. Large blobs of color with no detail and excess graininess in reproductions also cause customers to complain.

# REPRODUCING COLOR

## All color starts with light

Color is a visual sensation that involves a light source, colored objects and a human observer's eyes and brain. These elements interact with one another to produce the color sensation. The human eye is sensitive to red light, green light and blue light. The object absorbs a portion of the light illuminating it and reflects a portion to the observer's eyes. The color seen depends on how much red, green and blue light reaches the eyes. Objects in low light levels can be seen, but the eyes may be unable to detect color. Years ago a famous artist said, "All color looks the same in the dark." He was very observant indeed.

Any object appears colored because it possesses pigments or dyes that either absorb, transmit or reflect some portion of the light illuminating it. The object's color depends on the illuminating light's color. The visual effect can be quite different depending on the condition of the object, light source, viewing conditions and observer.

The light quality reaching the observer's eyes determines what color the object appears. Therefore, anything that changes the illuminating light's color, also changes the color of the reflected light and thus changes the perceived color seen by the observer. This explains why standard viewing conditions with a constant light color and uniform intensity are important for consistency when evaluating color at different locations, evaluating press sheets at different time intervals, comparing the original with the proof, or comparing the press sheet with the OK proof.

## Color attributes

Color has three important attributes, *hue, saturation* and **brightness**. All three are controlled to produce color reproductions.

*Hue* describes the "color" of a color, whether it is red, green, blue, cyan, magenta, yellow, chartreuse, aqua or another descriptor. Hue results from the dominant light wavelength.

*Saturation* describes the color's strength and its departure from gray. The color's saturation may vary from strong to weak. An example of changing saturation is adding pigment to a clear ink vehicle. As more pigment is added the color increases in saturation. The hue does not change, but the strength increases.

*Brightness* describes a color's lightness or darkness, regardless of the color's saturation or hue. For example, a very saturated red can be either very dark like a rich wine or bright like a red geranium.

## Additive color theory

Additive color theory describes how light colors added together produce other colors. If the rainbow is divided into approximate thirds, the three predominant colors are red, green and blue light.

To demonstrate the additivity of these three light primary colors, project a red light, a green light and a blue light onto a white surface. Where all three colors overlap, the observer has the sensation of white. Where only two of the light colors overlap, the resulting color is cyan, magenta or yellow. When no light illuminates the white surface, the result is black. Differing amounts of all three additive light colors produce the *visible spectrum,* or *color gamut.* The visible spectrum, or color gamut, indicates the full color range that the human eye can perceive.

*Figure 1  Additive color red, green and blue light*

*Figure 2  Subtractive color cyan, magenta and yellow pigments*

### Subtractive color theory:
### reproducing colors with pigments and inks on a white surface

The subtractive color process is used in printing color reproductions on a white substrate, such as paper. All the color that is going to be visible on paper is already on it. White paper is white because all the white light shining on its surface reflects back to the human eyes. The red, green and blue light portions added together make white light.

the unwanted contamination. This problem is addressed later in this book, see Color correction, page 66.

## Hue, saturation and brightness

Using most printing processes, it is possible to match the hue of the original colors in the reproduction by varying the ink-film thicknesses. The various hues, saturations and brightnesses are created by printing each process color with varying-sized halftone dots. Digital systems electronically generate these dots during film output. From 0 to 100 percent dot sizes for each process color are printed in any area of the reproduction. In any given area, from 0 percent dot to 400 percent dot may be printed. If 100 percent of all four colors print in one area, 400 percent dot happens.

These dots are so small that the human eye cannot resolve them without a magnifying glass. The color that is seen is the result of the combined light absorbed by the ink dots and the light reflected by the paper. The reflected light has been blended into a color with a given hue, saturation and brightness. The fact that this light mixture is seen, and not the dots, is called *mosaic fusion*.

## Color balance

A color reproduction should appear to have each color strength correct relative to all other color strengths. Once each color's correct dot sizes, or ink amount, is determined for color balance, the balance must be maintained. If one color becomes too heavy, it may produce a color cast. When color control adjustments are made, color balance is more important to hue consistency than the exact amount of color strength.

# OVERVIEW OF THE
# COLOR REPRODUCTION PROCESS

To this point, the discussion has been limited to color theory. Good color reproduction duplicates the original scene with ink on paper, using the halftone printing process. Before digging into the details of each production step, consider the following synopsis of the color reproduction cycle.

It should be noted that at every color reproduction stage the following is necessary:

- Visually evaluate each resulting product, intermediate film or proof.
- Measure, optimize and control the production processes.
- Communicate anticipations, desires and changes accurately.

### Start with the copy

*Copy* or *original* describes any material to be reproduced. The original scene, painting, drawing or product is captured on photographic film or with a digital camera. The photographic film results in a transparency or a reflection print made from the transparency or color negative. The transparency may be referred to as a "slide," "chrome," or "tranny." The copy also may be a digital magnetic disk, optical disc, or a magnetic tape.

The designer or photographer views the copy and selects the one that has what is desired for the reproduction. Then s/he must

observer's eyes. Note: with process colors, the paper reflects the light, not the inks. This means that the paper surface plays a major role in the color's appearance. See the subtractive color illustration in Figure 2.

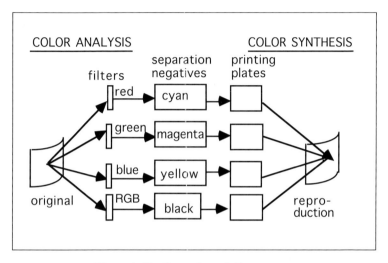

*Figure 4  The four-color printing process*

If any two of the process inks are printed together, they absorb two thirds of the visible spectrum and create overprint colors of red (R), green (G) or blue (B). If all three inks are printed over one another, all light is absorbed resulting in black. However, in actual practice the three-color overprint appears brown and is not as dark as desired. Therefore, to achieve the shadow area darkness, a black ink is also printed. Since an old letterpress term for black is *key*, the black in four-color process is identified with the capital letter "K." This prevents confusion with the "B" for blue.

Process inks are not pure colors. Therefore, when you are making color halftone separations, you have to make minor corrections for

In the four-color printing process, color is created on the substrate by using three transparent pigments, cyan, magenta and yellow inks, as filters. They are called *process colors* or *process inks* and are usually identified using the capital letters C, M and Y. Each should absorb one third of the visible spectrum and transmit two thirds.

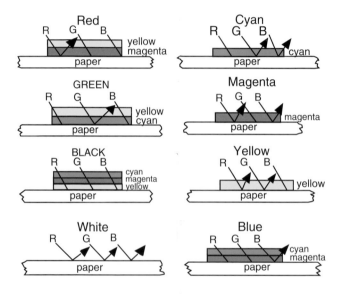

*Figure 3  Color absorption/reflection*

In other words, the ink pigments subtract some of the light. Cyan ink absorbs red light. Magenta ink absorbs green light. Yellow ink absorbs blue light. When red light is absorbed, green and blue light is reflected, and the observer sees cyan. When green light is absorbed, the red and blue light is reflected and the observer sees magenta. When the blue light is absorbed, the red and green light is reflected and the observer sees yellow. The inks absorb a portion of the light and the paper reflects the unabsorbed portions to the

decide how the original should be reproduced and communicate this to the person making the color separation. Often the instruction is "match the chrome." However, more often, there are additional instructions for minor changes to improve the copy's appearance, such as "Open up the shadows," "Make the whites neutral," "Darken the blue sky," or "Take the redness out of the skin." Whatever the desired appearance, it is extremely important to communicate these changes correctly to the separator. Improper communication results in extra color correction later at added expense to the customer.

*Figure 5  The cyan separation, magenta separation, yellow separation, black separation and the four-color reproduction*

## Make the separations

A *set of color separations* are made from the original copy on an electronic color scanner. The transparency, print or negative is analyzed through a red filter, a green filter and a blue filter. The copy's cyan, magenta and yellow amounts are examined to determine how much cyan ink, magenta ink and yellow ink are needed to reproduce this original copy. A separation or printer is made for the cyan, the magenta and the yellow. To achieve better shadow density and detail, a black separation or printer is also produced. During the separation process, contrast, color saturation and color balance adjustments create the desired look. Standard halftone screen values can be used to reproduce the original as it appears. More often, the customer desires some subjective modifications to improve the look of the reproduced original. The scanner used for the separations can make a difference in the final reproduction's color quality and detail.

## Verify the separations

A *color proof* is used to determine that the separation is correct. A color proof visually simulates the printed image; it represents the hues, detail and contrast of the image that will be printed. These color proofs are called *scatter proofs* or *random proofs* because each verifies only the color separations—not the completed page.

A color proof made directly from the color separation digital file can be a *soft proof* or a *direct digital color proof (DDCP)*. The soft proof is viewed on a computer monitor screen. A direct digital color proof is made on an electronic printer and uses pigments or dyes on a white substrate to simulate the ink on paper. It may or may not contain halftone dots. *Analog proofs* are made using the halftone films produced from the digital files on an imagesetter or film plotter. The analog proof can be an *overlay proof* or a *single-sheet proof*. With

the overlay proof, each layer of process color is on a separate carrier sheet superimposed on a piece of white paper. A single-sheet proof transfers each process color to a white carrier sheet to simulate the printing.

## Produce the halftones

*Halftones* are grids of equally spaced dots that simulate the different tones of the original by transforming them into dots of varying diameter. Halftones are necessary because most printing presses cannot print variable amounts of ink. Each color's strength is achieved by printing dot sizes that vary from 0 percent to 100 percent in any area of the image. The *screen ruling*, the number of dots per inch in each grid row, is chosen to minimize the dot gain for a given press and paper type. The higher the screen ruling, the more dots per inch and the finer the screen ruling.

The screen angles are adjusted to produce the normal circular rosette pattern and to minimize moiré. If the four halftones were printed directly over one another, an objectionable pattern, called *moiré*, would result. To minimize moiré, halftones are angled at a nearly 30° difference between the strong colors. Usually, yellow is angled at a 15° difference from the strong colors. While making the halftone separations, the operator selects this angling so that films with the proper angles are output on the imagesetter or on the film plotter of a color scanner or color electronic prepress system (CEPS). *Stochastic halftone screening* does not produce moiré and, therefore, does not have to be angled. Stochastic halftone screening uses algorithms to make halftones by varying the number of dots in an area to achieve differing tonal values. The dots are very small and all the same size. Some newer algorithms can also vary the dot sizes. See *Stochastic halftone screening* on page 86.

## Import the digital color separation halftones into an electronic page layout

Once the color separations are deemed correct, they are placed into an electronic page using a page-layout program, such as Aldus

*Figure 6 An enlarged halftone pattern of the color angles*

*Figure 7 A moiré pattern*

PageMaker or QuarkXPress. At this point, the color separations are stored in a digital file as gray levels, not halftone values. The halftones are created when the entire page is output on an image-setter or film plotter.

The completed page is proofed either as a direct digital or analog color proof. A direct digital color proof is made by ink jet printer, thermal transfer process, color laser printer, or color copier. An ana-log color proof is made from the films produced on the imagesetter. After viewing the proof, any changes needed to correct the repro-duction's appearance are made to the digital file, and a new direct digital color proof is made, or in the case of an analog proof, another set of halftone films is produced and proofed.

## Make printing plates or gravure cylinders

*A printing plate* or *gravure cylinder*, often called the image carrier, transfers the inks from the press to the paper substrate. Printing plates have a light sensitive layer that is exposed with light through the halftone negative or positive. After the image is processed, the printing areas accept ink and make the transfer on press. Gravure cylinders are made by etching or engraving small cells into the cylinder surface. The cells carry the correct amount of ink to the paper. The platemaking or cylinder making step must be controlled accurately to transfer the correct halftone dot sizes from the films or digital files to the paper.

## Control the press to achieve the desired effect

On the printing press, printing is adjusted to make the printed result match the color proof as precisely as possible. Some color proofing materials have a different gloss than the ink that penetrated the paper. Therefore, it is possible that the printing may not exactly match the color proof. In this case, the customer or press operator must determine when the desired effect has been achieved. Often the customer prefers to be present at the beginning of the pressrun and give an OK to the accepted result. When the customer evaluates a press sheet taken from the press during the makeready or from the beginning of the pressrun, marks it "OK" and signs it, it is called an *OK press sheet*, *OK sheet*, *pass sheet* or *color OK*. It is used as a color-quality control guide during the rest of the pressrun.

Controlling the press for consistency is the press operator's job. The operator must adjust the ink amounts and other press settings to maintain the appearance of the printing so that it matches the OK press sheet. Technological developments are making it easier to measure and control the printing.

# STANDARD VIEWING CONDITIONS AND PROCEDURES

Because color reproduction is a subjective process, it is imperative that everyone view color under the same conditions. The nature of the light illuminating transparencies, color proofs or press sheets can change their appearance. Using the viewing conditions established as the worldwide standard, there is assurance that color viewed at different locations will be seen the same.

The following is a description of standard viewing conditions and procedures you should use:

1. The color of the light source must be equal to a black body heated to 5000 degrees Kelvin. There usually is an indication on the color viewing booth that it has a 5000K color temperature. On the viewing surface, the light intensity should be about 200 foot candles in strength.

2. The light's color rendering index should be 90 to 100%, meaning that all wavelengths of light are represented. This is a difficult attribute to measure. You have to assume that the manufacturer of the color viewing booth built the booth accurately.

3. There should be a neutral gray surround on three sides of the viewing area to keep out stray light from other sources.

4. Put the transparency viewer inside the color viewing booth, so that the overhead light is on when looking at the transparency. This helps to insure that the transparency and the color proof are viewed in a similar manner. Do not look at the transparency under darkened room conditions and at color proofs under lighted conditions. This will very quickly

lead you astray. Under these conditions the original and the proof will not match.

5. View large format transparencies with a 2 inch white surround. This helps you to view the transparency under optical conditions that will be very similar to those when viewing the color proof and the press sheet.

6. Allow the bulbs to warm up for 15 minutes before viewing color. During the warm-up period the lights are definitely more pink and not standard.

7. All viewer bulbs should be changed after every 2500 hours of use. Viewer bulbs alter their color temperature as they age. The change is gradual and not always apparent. Users of viewing booths are often lax about bulb maintenance, and the transparency viewers' colors are not the same, because the bulbs have not been changed. A quick check of color consistency can be done by just standing at a distance where you can see all the viewers at the same time. Instantly, the color differences will be apparent. To certify the viewing booths are within specifications, it is best to have the manufacturer measure the color temperature and intensity.

A small format viewer with standard viewing conditions is available for 35 mm transparencies. It enlarges the transparency about seven times.

Another viewer is available for making side-by-side comparisons of images, such as transparencies and press sheets, and video monitor images. This viewer is about the same size as the monitor and has a light source that can be varied in intensity. When making comparisons, the viewer and monitor are placed side by side.

Video monitors should also be calibrated to 5000K. The software that may be built into the monitor, or that accompanies color management programs, allows for monitor color balance adjustment.

*Figure 8  A GTI color viewing booth with a Vari-Tech scanner drum transparency viewer*

*Figure 9  A BL Mega viewer above and a GTI Soft-View below, two different small size standard viewers*

There has been some talk that a slightly higher color temperature should be used for monitors. As yet, the specification has not been changed.

Viewing transparencies on scanner drums is difficult because the viewing lamps on many scanners are not 5000K. A special device is available that allows you to place your scanner drum over a 5000K light, so that the color proof and the transparency are viewed accurately side by side in the viewing booth.

# COLOR COMMUNICATION

*Accurate communication is the key to producing quality color reproductions.*

**Side by side comparisons—a must!**

When viewing two colored objects for comparison, such as a color proof and a transparency or press sheet, keep in mind that the human eye is connected to the brain. It is not very accurate at remembering the attributes of a color even over a short period of time. However, people can make very accurate side by side comparisons to determine if two colors are identical in hue, strength and brightness.

> *When making color comparisons, always have both objects in view side by side, so that they are seen simultaneously. A person should never look at one object, and then, look away at another object.*

**Buzz words**

Often, when we, the customers, don't get what we want the first time, it's because of a lack of accurate instructions. The customer or the customer's representative chooses the copy. It may be a transparency or print that represents the original product or scene. The customer indicates how the image should be reproduced. The sales person must communicate these desired attributes to the color

separator, retoucher, press operator and quality control person. If a change is needed, the modification is usually put into words and these instructions are passed along. Herein lies the problem. A description of what is seen, or what is generally wanted, such as "improve the flesh tones," does not tell the person responsible for making the change exactly what is expected. The instruction should specify the change needed, such as "make the flesh tones more warm, or remove the sunburned appearance of the skin tones." The more accurately you can communicate color verbally to others, the more likely you are to get the desired result.

Earlier than 1979, a conference sponsored by the Research and Engineering Council began to develop a list of words that people use to describe what they see and what they want. Over the year, this author enlarged the list to what became known as the "Buzz words." Many of them are very vague. You must be very precise in your instructions for color changes.

| | |
|---|---|
| add contrast | color OK but thin |
| add density | color OK but too heavy |
| add snap | color too skinny |
| air out | colors all jammed up |
| balance the neutrals | colors too strong |
| beef up color | commercially acceptable color |
| blown-out | contrasty |
| blue out | cooler |
| burn down | crisp color |
| burner | delete a little red |
| chalky | dirty and flat |
| choked up | do a little better here |
| choppy midtones | does not have shine of trans- |
| chunky | parency |
| clean up | dull down |
| color OK but flat | eliminate the hot spots |
| color OK but more density | exaggerate the condition |

flesh needs weight and color
fleshier face tones
flick less
Give it a kiss wash.
Give it a strong wash.
Give me more shape.
Give me pleasing color.
Give me a pretty picture.
Give the reds a bump.
grainy
Greek out
grubby
harsh
hold highlight
I want the red to jump off the page.
improve the flesh tone
increase the contrast in middle-tones
increase detail
increase highlight separation
increase saturation
increase sharpness
It doesn't do anything for me.
It's got to be livelier.
It's got to jump.
lacks snap
maintain gray balance
make colors cleaner
make colors colder
make colors warmer
make it brighter
make it glossier
make it pop
make it sing

make it sky blue
match attached
match copy
match the crossover
Moiré!!!
more guts or gutsier
more metallic
more neutral
more sock
more texture
muddy
mushy
needs dimension
needs luminosity
needs more depth
needs warmth
N.G. or no good
N.G. reseparate
N.G. try again
neutral brown
OK!!!
OK???
OK with correction
open up shadow
out of color balance
over-etched, see 1st proof
plugged
pushy
raw
redder reds
reduce blue 2 1/2%
reduce one more step
reduce overall
refer to first proof
ruddy

seems cloudy
seems fuzzy
+ shape
soften black
strengthen
subdue
tad less
tone down
too dull
too flat
too hot or cold
too jumpy

too much internal contrast
too muddy
too pinny
too weak
UGH!
Whew!
whisper more
whiter whites, but hold detail
wrong shade of red
yellow OK, but see the proofs
You went too far!

## Color measurements

Today, color can be measured to determine whether two colors match in hue, saturation and brightness. A hand-held colorimeter can indicate the exact color specifications of a color being measured and can compute how different two colors are. The result of the calculation is called a *delta E value*, or **ΔE**. One delta E is not easily noticed, two delta Es are slightly noticeable and three delta Es are quite noticeable. See Densitometers and colorimeters, page 105.

## Standard color references

Measurements work for color comparisons, color specifications or color control for consistency. However, most of the time, people prefer to compare a color to a standard color reference. Color reference patches, color charts, color tint books and fan books are available from Agfa Division of Miles Corporation (computer generated patches), Focoltone, Pantone, The Tint File and TRUMATCH. These samples can be used as side by side viewing color references when

trying to get what is desired. By adjusting the amount of cyan, magenta and yellow, the press operator can get the desired color on a given substrate. Note: when using the same ink combination and dot sizes, a glossy substrate produces a different hue, saturation and brightness than a matte surface. Available software will modify a video monitor color to match what will be produced on the press sheet using given dot percentages.

*Figure 10  TRUMATCH and Pantone color references*

*Figure 11  Swatching out with standard color references*

**Swatching out** is a technique of using standard color patches for visual comparison with a color original, color proof or press sheet. Using this method, it can be determined if the dot values as read on film, or with the densitometer function on the computer monitor, will produce the desired color. Often, swatches are used as the physical reference because the computer monitor cannot accurately display the color.

# CHOOSING AN
# ORIGINAL FOR REPRODUCTION

If you have a choice of originals for reproduction, or you can specify the film your photographer uses, you should consider such attributes as emulsion type, graininess, detail, contrast, exposure level and color balance. Of these attributes, **detail** is the most important.

*If you have a choice of transparencies of the same scene, choose the transparency that most looks like the reproduction you're trying to achieve.*

The image for reproduction should be sharp, in focus and without a color cast. The highlights should be slightly darker than normal as that will insure more highlight detail. It is easier to lighten the highlight than to invent detail that is not there.

### Positive or negative film originals?

Usually, reproductions made from transparencies are better than reproductions made from reflection prints. Making a print from a color negative film adds another generation to the process and adds print graininess to the final reproduction. With many of today's electronic color scanners, it is possible to separate directly from color negative film, thereby giving more sharpness than from the print. The problem of using color negatives as originals is that the film appears orange and is composed of negative color. This makes it difficult to judge the color original without scanning it and evaluating

it on the computer's color monitor. However, tests have shown that reproductions made from color negatives can be as good as reproductions made from Kodachrome film.

**Film emulsion, format speed and exposure**

Most customers prefer good detail in a color reproduction. The best detail is achieved by choosing a film with very fine grain sizes and a large format, so that more film emulsion grains capture the original scene's detail. It once was common to specify large-format Ektachrome film. Now, with the finer grained 35 mm Kodachrome film, the photographer can get the same sharpness with the smaller format. The new color negative films also have fine grain and good exposure latitude.

The most unwanted reproduction attributes are graininess and unsharpness. *Graininess* is a pebbly rather than smooth appearance. It may be caused by film emulsions without enough grains to capture the image. Film speed also influences the fineness of the film's grain. Slower-speed films have finer grain. High-speed films have larger grains. Therefore, they capture less original scene detail. This restricts how much higher-speed film reproductions can be enlarged without appearing very grainy. The scanner's unsharp masking function may exaggerate the film graininess.

If a very large reproduction is desired, a large-format, fine-grain film should be used. A 2 1/4 by 2 1/4 inch or 4 by 5 inch film can be enlarged more times than a 35 mm image without detail loss.

*Unsharp* or *out of focus* originals look fuzzy. Objects and buildings lack sharp edges. The cause may be images that were photographed out of focus. The photographer may have chosen the wrong film emulsion type and film speed. Some compensation for unsharpness may be possible during the separation process.

*Exposure level* is the quantity of light that is allowed to fall on the photographic film. The exposure level used by the photographer affects the densities in the highlight and shadow, and the color saturation. If the transparency exposure is too much, the highlights lose detail and appear washed out. If the exposure is too low, the highlights are too dark and the detail is hidden.

*Figure 12  A high key image*          *Figure 13  A low key image*

### The copy's keyness, contrast and color balance

*Keyness* describes the distribution of the densities, or tonal values, in the original between the highlight and shadow. If the original's detail is evenly distributed over the whole density range (highlights, middletones and shadows), it is described as *normal key.* If the original is dark with no or few highlights and most of the detail in the shadow areas, it is described as *low key*. If the original has most of its detail in the highlight area, such as a white egg on snow, it is described as *high key*. Usually, the normal key original reproduces with the best result. However, compensation can be made for high and low key originals during the separation process.

*Contrast* refers to the difference between image light and dark areas. It is the tonal gradation between the highlights, middletones and shadows. The type of lighting used when the original scene was photographed influences contrast. If there was harsh lighting, the contrast appears very high. The shadows and dark areas probably have less detail. Softer lighting results in lower contrast and is easier to reproduce. Some originals are described as being *flat*. This means that there is not enough contrast. This causes all colors to look faded and desaturated, or all colors to look too dark and saturated. For more information about contrast, see The importance of contrast for optimum color, page 48, and Ideal contrast for clean, bright colors, page 50.

*Color balance* is the original's overall color appearance. If the image looks pleasing, the color balance is probably OK. However, if the entire picture has a yellow cast because it was photographed late in the day or because of a film processing problem, the color is out of balance. This overall color cast is undesirable. You may be able to remove it.

When assessing the image's color balance, first determine that the memory colors are correct. These, along with white objects, give you a clue that there is a problem. If you want to see a different color balance, look at the transparency through *Kodak Print Viewing Filters* in a viewing booth. By using different strength cyan, magenta or yellow filters, you can observe how the transparency would appear if the separation were adjusted. See What customers expect color reproductions to look like, page 1.

## Digital original evaluation

If the original was captured with a digital camera, its evaluation is only possible after the separation has been made, and the image is viewed on a computer color monitor. As mentioned earlier, this is

also the only way to view a color negative image, unless you have a color print made from the color negative.

## Digital images require further processing to be accurate

A digital camera captures an image to make a color photographic print. To make a photomechanical reproduction, it is necessary to perform the normal separation adjustments for the chosen printing conditions.

| original | original | original |
|---|---|---|
| ↓ | ↓ | ↓ |
| desktop scan | hi-res | FPO scan* |
| ↓ | highend scan | ↓ |
| desktop | ↓ | desktop design and |
| page makeup | desktop | page makeup |
| ↓ | page makeup | ↓ |
| digital proof | ↓ | to separator for |
| ↓ | digital proof | hi-res and new FPO |
| digital print | ↓ | highend scans |
| | input to CEPS | ↓ |
| or | for correction | FPO replaced |
| | ↓ | with new FPO |
| | | digital proof of hi-res |
| output film | output film | ↓ |
| ↓ | ↓ | corrections, APR |
| plate and print | analog proof | and film output |
| | ↓ | ↓ |
| | plate and print | analog proof |
| | | ↓ |
| | | plate and print |

APR    automatic picture replacement                FPO    for positon only
CEPS   color electronic prepress system             hi res  high resolution
* scan methods vary, FPO only, flatbed or desktop scanner

*Figure 14  Three color separation workflow examples*

# MAKING COLOR SEPARATIONS

Color prepress has changed quickly and dramatically. Probably 99.9 percent of all color separations are now electronically scanned. The majority of color page makeup is done electronically using either a color electronic prepress system (CEPS), or Macintosh or PC. The workflow depends on how much retouching and separation customizing the customer wants to do and how much is delegated to the trade shop, service bureau or printer. With automatic picture placement, the customer makes up pages using low resolution *for position only* (FPO) image files. The high resolution files are substituted when the films are produced. Today, very little page makeup is done on the stripping tables.

### System configurations and workflow

When making color separations, the workflow can follow many different paths. Each will satisfy the production steps for a given throughput, system configuration and quality need. The sequence of events depends on the process used to import FPO separations and high resolution separations into the files that are used to make the final films. In Figure 14, there are three workflow examples.

### Choosing a color scanner

The scanner you select will influence your image quality, your productivity and your throughput. Scanners are generally rated

for producing separations from the best quality to lesser quality in this order: highend scanners, desktop drum scanners and CCD scanners. The Kodak Photo CD separations' quality is about equal with midrange, desktop drum scanner separations' quality. The digital still camera produces separations with a quality level not quite equal to a CCD scanner.

### Highend, desktop, OPI, APR

Communication connections have been developed that facilitate links between CEPS and desktop publishing systems. Using software, viewfiles of full resolution scans can be transferred from a CEPS to a desktop publishing system and placed in a page layout file. When the page file is sent back to the CEPS for processing and output, the high resolution image data is automatically swapped for the viewfile. *OPI,* Open Prepress Interface, by Aldus Corporation is now frequently used by any system that seeks to maintain high resolution image data separate from page layout files. *APR*, automatic picture replacement, is the term used by Scitex to describe this feature. It functions much like OPI. OPI is often compared to *DCS*, a data file standard defined by Quark.

### Color scanner setup and operation

Regardless of the workflow, every color separation must meet production requirements based on the printing conditions and customer's desires. To meet these demands, the scanner settings are adjusted prior to scanning, or the digital files are adjusted after the scans are made. Usually, the skills needed to operate a highend scanner are more complex than the skills needed to operate a desktop type scanner that is controlled from the computer keyboard. The prepress process knowledge needed is about the same whether highend scans or desktop scans are made.

### How a highend scanner operates

In the worldwide graphic arts industry, the highend scanner has become the ultimate benchmark for the best quality color reproduction. Even though some desktop drum scanners and CCD scanners can almost match the quality of the highend scanner, it still makes the best separations. "Highend" refers to the price and the quality. Those in the printing industry know what it takes to produce good quality color on the printing press. Regardless of how the separations are made, it's still necessary to adjust the separations to the printing parameters.

*Figure 15  A typical highend color scanner, Screen (USA) 737 pictured*

When running a highend scanner, the operator mounts the color transparency by taping it in position on a clear plastic cylinder or drum. The scanner analyzes the transparency point by point using light that shines first through the center of the drum and then through the transparency to the scanner optics. There the light splits into three beams that respectively pass through the red, the green and the blue filters. Information from the filters is used by the scanner to produce the four separations.

The scanner drum revolves at a high speed. During each revolution, the optics look at one row of information around that drum. Each row is made up of small spots called *pixels*. A pixel may vary from 1/100 of an inch to about one thousandth of an inch in diameter. During the analysis of each spot, before the scanner optics moves to the next spot, the light beam splits, passes through the red, green and blue filters and images onto a photomultiplier tube. The photomultiplier tubes are sensitive to the different light levels. The photomultiplier tubes measure the amount of red, green and blue light passing through from the original. The strength of the signals indicate the amount of cyan, magenta and yellow content in each spot of the original copy. A temporary scanner memory stores each row of pixel information. Each pixel in that row is recorded as one of 256 gray levels for each process color. At this point the color appears only as a level of gray. It no longer is a color.

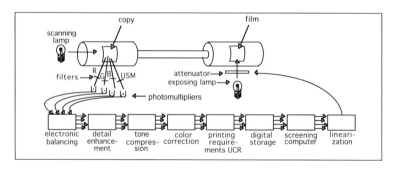

*Figure 16  Simplified schematic of a highend color scanner*

As the cylinder revolves one revolution, the scanner samples the pixels around the drum, analyzes them and records a value for the cyan, magenta and yellow for each pixel. To compute the black amount needed in each pixel, the highend scanner analyzes the three values for each pixel. When all three signals (cyan, magenta and yellow) are heavy, there is quite a bit of black present. If only two are heavy, then

the color is not black. It may be a saturated color. Therefore, the area needs no black or very little black.

After the cylinder has made one revolution, the scanner optics move over the width of one scan line, which is equal to the spot size. The cylinder makes the next revolution. The scanner repeats the process until the entire original image is scanned.

For immediate separation film output, film is mounted on a separate revolving solid scanner drum. Exposing optics record the dot sizes necessary for the cyan, magenta, yellow and black halftone separations. With each revolution, one half a row of halftone dots is recorded. As a typical highend scanner analyzes and records each scan line, the scanner simultaneously records the previous scan line output onto the halftone film or stores the information on a magnetic disk or tape for input into the page later. The scanner exposes or stores the images at the correct size for the finished color reproduction. Four halftone separation negatives or positives, ready for color proofing and manual stripping into a color page, are produced.

**The** *sampling rate,* or the number of pixels per inch scanned on an original, is determined by the final reproduction size and resolution. The *resolution* is the degree of detail in the output, in this case the separations. Unsharp masking, which is described later in this book, can enhance the image resolution, because it increases the edge sharpness. The resolution of input and output devices is often described by their rated pixels per inch or dots per inch (dpi).

| | |
|---|---|
| Macintosh monitor .......... | 72 pixels per inch |
| Laser printers ............................ | 300-1200 dpi |
| Imagesetters .............................. | 1270-3386 dpi |
| Desktop scanners ................. | 300 to 6000 dpi |
| Highend scanners ............... | up to 10,000 dpi |

In the graphic arts industry, it is customary to scan in two pixels for every halftone dot in both directions at the final size of the

reproduction. These four pixels per dot are sufficient information to give the detail or resolution needed in the final reproduction. Most highend scanners output films using two passes around the drum per row of halftone dots. That means for a same size reproduction using a 150 line screen, the scanner input scans at 300 pixels per inch, which is equivalent to 300 lines per inch (lpi), to output 150 rows of dots per inch. Output requires two exposure passes to produce one row of dots, or 2.0 pixels per output halftone screen dot in each direction. The industry is moving toward using only 1.5 pixels per output halftone screen dot in each direction, because that seems to be sufficient.

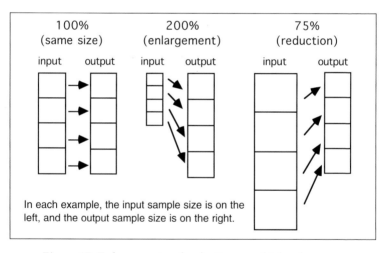

*Figure 17  Enlargement and reduction on a highend scanner*

If the size of the reproduction differs from the size of the original, the operator sets the scanner to alter its input scanning rate as compared with its output scanning rate. The output exposure frequency is not changed; only the input scan frequency is modified. A reproduction that is twice as big in both directions as the original requires a 200 percent magnification. Using a 150 line screen output, the input is

scanned in at 600 pixels and lines per inch frequency for 150 lines per inch output. There will have to be twice as many rows of dots as there would be for a 100 percent reproduction. When the reproduction enlargement size is entered during scanner setup, the scanner automatically increases the input scan frequency to produce the correct output size. When the pixels are output at normal scanner 300 lpi frequency for the 150 screen ruling, the reproduction will be the correct enlarged size. Enlarged highend scanner reproductions usually have better detail than enlarged CCD (charge-coupled device) scanner reproductions, because the highend scanner has the ability to increase the input sampling rate. If needed, the highend scanner takes many more samples from the same original. See How a desktop CCD color scanner works, page 40.

The more information the scanner obtains from the original during the scanning process, the larger the reproduction could be. Of course, the disadvantage of recording large amounts of original pixels is the large file size created. If you convert this large file to a Mac or PC file, the file size makes the task more difficult. To minimize the file size and the processing time, you should scan for the anticipated reproduction size.

The amount of color picture data may cause the file size to become cumbersome. For example, a one square inch area screened for a 150 line halftone contains 22,500 dots per color. Multiplying 22,500 dots by four colors produces 90,000 dots. Multiplying 90,000 dots by four pixels per dot gives 360,000 pixels for a one square inch area. A 2 by 3 inch image contains 1.6 megabytes (Mb) for each file created. A 4 by 5 inch image contains 5.4 Mb. A full 8 by 10 inch page would contain 21.6 Mb for each file. Therefore, you can see why sampling at only 1.5 pixels or 1.2 pixels per halftone dot helps considerably to reduce the file size.

Questions are often asked about the differences between analog and digital scanners. It is interesting to note that all highend scanners are

both analog and digital. That is, the original information is scanned in as analog data and converted to digital data. At some point in the color separation process, the scanner modifies the optical signal to a digital gray value, or gray level.

An *analog scanner* receives each light signal and converts the optical signal to an electrical signal of 0 to 10 volts. The scanner analyzes and processes the information as the voltages pass through built-in hard-wired circuits of resistors and transistors. Late in the scanning process, the analog scanner digitizes the information for storage in a temporary buffer. It holds a single row of pixel values for one revolution of the input cylinder before the data is output.

A *digital scanner* immediately digitizes the analyzed analog information from the photomultiplier tubes. This scanner processes the information digitally. This makes it possible to build algorithms for making the calculations in the software. The manipulated digital data is stored in a temporary buffer before output to film. The digital data also may be stored in its entirety on a magnetic disk for later output to an electronic page.

### Analyzing the separations prior to making films

In the early days of scanning, it was not possible to view the scanned image prior to making the films. Scanner operators "flew by the seat of their pants" and hoped that they had done everything correctly for a good reproduction. Over the years, skilled operators learned what is needed to produce good reproductions. They could be confident in the results. Only after the analog color proof became available did the scanner operator and the customer know for sure that the separations would produce good reproductions. Before the digital color proof, the national average for getting an acceptable set of separations was three scans and three analog color proofs.

Today a highend scanner is linked with a color electronic prepress system or a desktop computer. Instead of sending the output pixel information to film, the scanner sends the entire four separations to a disk for digital storage. The digitally stored scanned image can be viewed on a monitor prior to making films. This not only permits anyone to view the scanned results, it facilitates either changing the scanned data to make a better image, or making the decision to rescan the image.

A color electronic prepress system (CEPS) is considered a highend retouching station. It has very high processing power and high throughput, as well as a high price tag. A CEPS allows the operator to view, retouch, modify and incorporate images into pages or flats for later output to digital color proofs, page film, direct to plates, gravure cylinders or to a digital press. The text for the pages is usually imported. Images from the CEPS can be archived to magnetic disks, optical discs or data tapes.

Computer and peripheral manufacturers have improved the desktop computer's speed and funtionality. While it does not yet match the CEPS in speed, desktop prepress can now perform most of the functions of a CEPS. Desktop prepress has substantially lowered the cost of making up pages electronically. Now it is possible for document creators to make up pages themselves on their desktop computers. They can either make the color scans themselves, or ask their separator or printer to make the scans. The scanned images are placed in the pages during film output. Additional color correction, retouching and image merging can be done by the designer. This workflow gives the customer more control, design flexibility, later closing times and lower prepress costs. While the desktop computer makes it possible for more color pages to be produced, it poses a threat to the traditional prepress house. Now customers prepare and deliver digital pages on Syquest or optical discs to the printer, who offers services formally provided by the service bureau or trade shop.

**Screen DS-608**
highend color scanner with
on the fly USM, color cor-
rection and CMYK output

**Optronics ColorGetter**
desktop drum color
scanner

**Scitex Smart Scanner PS**
automatic flatbed scanner
Image captured and cus-
tomized with the Scitex
software.

*Figure 18A  Comparison of scans from different input color scanners*

**Howtek D-4000**
desktop drum color scanner

**Agfa Horizon**
desktop flatbed color scanner

**Kodak Photo CD**
35mm color scanner
Image obtained with Kodak
Acquire Photoshop plug-in
extension.

*Figure 18B  Comparison of scans from different input color scanners*

## Desktop drum scanners vs. highend scanners

When desktop drum color scanners are compared to highend scanners, the following differences and similarities are found. The desktop drum scanners. . .

- are much lower in cost than the highend scanners.
- try to emulate highend scanners. Their revolving drum and photomultiplier tubes analyze and capture the original image.
- function in much the same way as highend scanners. However, most desktop drum scanners do not carry out all the highend scanner functions.
- may give only red, green and blue (RGB) signal digital output. They may not be able to convert from RGB signals to CMYK (cyan, magenta, yellow and black) as a highend scanner does on the fly. The computer's separation software will convert the image to CMYK. You can avoid the transformation problems if you can work in CMYK from the start.
- will require the use of a computer and software to do color correction or unsharp masking after the original image has been scanned. The highend scanner does this on the fly, as it makes the separation and outputs the data.
- can be programmed and operated from the desktop computer to do multiple scans in an automatic mode without operator intervention. This is not possible with some highend scanners.
- cannot produce film directly like highend scanners do; an imagesetter is needed for film output.

## Desktop drum scanner costs

Desktop drum scanners are considered midrange scanners. Currently, they are available from such manufacturers as Howtek, Dainippon Screen, Optronics, Damark and others. There are over 50 manufacturers of all types of scanners. In 1993, midrange desktop

drum scanners cost anywhere from 10,000-60,000 U.S. dollars depending on the sophistication of the scanner and the options.

*Figure 19 Typical desktop drum scanner, Optronics ColorGetter pictured*

Most desktop drum scanners are controlled remotely from the Mac or PC. Preprogrammed from the desktop computer for each original mounted on the drum, the scanner scans each original, one after another, without operator intervention. This kind of operation is very cost-effective.

Compared with the highend scanner, the operation of the desktop drum scanner is relatively easy. This eliminates the cost and training time investments that are needed to become a highend scanner operator. A desktop scanner operator learns in a short time. Most guesswork is eliminated because the scans are made, and later adjusted visually for the printing conditions, based on the computer monitor image. Today's desktop color separation software facilitates the data adjustment for good color. "What you see is what you can expect to get in the reproduction."

## How a desktop CCD color scanner works

Generally, a CCD (charge-coupled device) color separation scanner is a flatbed device. The operator places the original reflection or transparent copy on a flat glass surface for color analysis. During the color analysis of the original, the light beam reflects from the original or transmits through the original to the photodetectors known as *CCDs*. These miniature sensors are arranged in a two-inch long, straight line on a computer chip called a *CCD array*. This CCD array may contain as many as 2000 sensors in the two-inch space. The CCD scanner may have one linear CCD array with filters that rotate over the CCD array to obtain the red, green and blue image. Or, more sophisticated desktop CCD color scanners have three parallel linear CCD arrays, one with a red filter, one with a green filter and one with a blue filter.

*Figure 20  Typical desktop CCD scanner, Afga Horizon pictured*

A desktop CCD color scanner analyzes the original by imaging the width of the picture over the length of its CCD array. Therefore, if the CCD array contains 2000 sensors, regardless of the width of the picture, a maximum of 2000 pixels are recorded across the width dimension. In a desktop CCD color scanner, the original moves

sideways over the stationary CCD array. As the original moves one width of the array, a snapshot is taken of each line of the original. When the entire picture is digitized and stored, either in the computer RAM or on a disk, the process is complete. If the scanner has three CCD arrays, the scan time is much faster than if the scanner requires a separate and successive red scan, green scan and blue scan of the original.

## Highend and desktop drum separations vs. CCD separations

Generally, CCDs (charge-coupled devices) have less dynamic range than photomultiplier tubes. *Dynamic range* is the range between the minimum and maximum density that the CCD can accurately detect. In an optical imaging device, it is a measure of the device's sensitivity range. (More information about dynamic range on page 48.)

CCD scanners are not able to sense the low light level differences in the dark shadow areas as well as desktop drum and highend scanners. This inability may cause the reproduction to have less detail and less color separation in the dark shadow areas than highend or desktop drum separations have.

The desktop CCD scanner resolution is more limited than highend or desktop drum scanner resolution. To change the desktop drum scanner reproduction sizes, the captured image data is mathematically adjusted. The amount of information already captured is either compressed or enlarged. With the CCD scanner, the amount of pixel information gathered is the same regardless of the original's size. If the number of CCD cells are sufficient to capture enough information for two pixels per dot across the image, then there will be no difficulty reproducing the original. However, to enlarge the reproduction, there may be a visible degradation of the image quality. This is because there will be less than two pixels per halftone dot in both directions. In some cases, 1.5 pixels or 1.2 pixels per halftone dot in each direction are sufficient.

Compared to the highend scanner, another CCD scanner disadvantage is that it generally cannot do unsharp masking or color correction on the fly. These two functions must be done after the scan is finished, using a PC or Mac and available software, and the stored digital information. This increases the throughput time.

## Digital still photography

The digital still camera is becoming a popular method of capturing images in a digital RGB color space for later use. The image is already in digital form. Therefore, production costs and throughput time are reduced. No film originals are necessary, and fewer steps are needed for color reproduction. Also, the photographer has an instant image with which to check the photographic results.

In general, digital still cameras are of two varieties: those using an area CCD that can be exposed by flash illumination, and those using a scanning linear CCD array that must be exposed by a continuous light source. Depending on the nature of the images being captured, one type or the other may be more appropriate.

Each new camera generation has improved image resolution. Currently it is not as high as photographic film or most color scanners. If you expect to keep the pixel to dot ratio of 2 to 1, the resolution limits the size of magnification possible. However, a digital camera does not have grain-like film. Therefore, the image can be mathematically enlarged by using fewer than two pixels per dot. The pixel to dot ratio can be reduced to 1 to 1, utilizing unsharp masking techniques to maintain image sharpness. While this does not create image detail that isn't in the original image, it does permit larger reproductions from digitally captured images.

As with other scanned images, digital photographic images must be modified for the printing conditions and customer's desires. This is done on the Mac or PC after photography and before page assembly.

**How the Kodak Photo CD system operates**

The Kodak Photo CD system uses a CCD scanner that scans in the original information at a 2,000 line per inch resolution with 12 bits per color. Kodak personnel determined that this scanning resolution will capture enough data to enlarge a 35 mm film image to a 16 by 20 inch color print with sufficient detail to equal an optically enlarged print. The RGB information for the entire 35 mm transparency is captured in a six second scan. The Pro Model scanner handles 4 by 5 inch copy and scans the original at 4,000 lines per inch on input.

Information is saved in the Kodak YCC color space format relative to the original scene rather than relative to the transparency. The RGB information is converted to luminance and chrominance. Y represents levels of brightness in luminance. CC values represent the hue in terms of chrominance. The color transforms used permit a color gamut large enough to support any color device. Each stored image is color balanced and adjusted for exposure. Therefore, originals with different characteristics can be used side by side in a final reproduction.

Using a prescan, a built-in algorithm returns the transparency's appearance to the appearance of the original scene. It adjusts the scene automatically to compensate for the original exposure and the film type that was used to capture the image. The software subtracts the characteristics of the film used. This makes the film type and film speed immaterial. It does not matter whether the original is negative, positive, Kodachrome, Ektachrome, Fujichrome or Agfachrome. Regardless of the film used, a reproduction identical to the original scene will be produced. This is a unique feature. It does not make images ready for printing. They still need the same image adjustments that other scans require.

There has been some rethinking of the desire to automatically return the reproduction's appearance to the original scene's color appearance. Most graphic arts people attempt to reproduce the original

transparency's appearance, rather than the appearance of the original scene before it was captured. This also may be desirable for Photo CD images. Therefore the automatic function can be turned off, so that the reproduction will be more accurate to the visual appearance of the scanned-in original.

Using the Kodak Photo CD system still requires that you customize the images for your printing conditions and the customer's desires. The Kodak algorithms cannot prepare the files for specific printing conditions because the system has no way of knowing what they are. Adjustments for contrast, color correction and USM (unsharp masking) are still required.

### Kodak Photo CD image storage and retrieval

The images are stored on a *CD (compact disc)*. This CD is similar in size and appearance to the disc used in your audio system. However, standard audio CD format is different from Photo CD format. It can only be read by compatible Photo CD ROM drives.

A consideration when buying a Photo CD ROM drive is whether or not it is a multi-session drive. A "session" is generally the placement of digitized images from one roll of film on the Photo CD disc. Add more images later, and it becomes a multi-session disc. Only multi-session drives can access multi-session discs.

The processed image captured by the Photo CD scanner is stored in the Kodak YCC color space format. A 35 mm transparency scan generates 18 megabytes (Mb) of information in an uncompressed format. A clever system of subsampling, image recomposition and data compression makes it possible to store as many as 100 images on a single disc. Only 6 megabytes of information per image are required with lossless compression. *Lossless compression* means that there is no loss of data during the data compression. This is con-

trasted with *lossy compression* where a high compression rate is achieved by sacrificing an acceptable amount of data.

Images can be retrieved from the CD ROM at different resolutions. Which resolution is chosen is determined by the size of the reproduction's enlargement. A unique hierarchical image encoding scheme facilitates image retrieval. High resolution components are compressed and decomposed for efficient storage. To provide quicker monitor access, low resolution images are not compressed. While current CD ROM devices read at about 150 kilobytes per second (Kbs), new drives will read two to four times faster. Still, image retrieval time is an issue.

### The Kodak Photo CD image pack

An *Image Pack* is the name given to all the image resolution components for one image on a disc. With a single high resolution scan of the 35 mm film to a Photo CD, there are five resolutions available. The process of creating these resolutions from a single scan is called a spatial decomposition. The five Photo CD image components and resolutions after image recomposition are shown in Figure 21.

Note that the scan done by the scanner is the highest resolution file, 16Base. This image is always available for retrieval. Uncompressed, the information alone would be 18 Mb. The Base/16 file is used for index files, icons and thumbnail images.

The Base (768 pixels by 512 lines) file is stored at the correct resolution for display on a TV monitor.

The 16Base scanned 18 Mb image is decomposed to provide the lower resolution files. The three highest resolutions are recorded to the Base image in a non-redundant fashion. A special method of encoding the images records only the differences between the higher

and lower resolutions. The highest resolution file is mathematically decomposed to a 4Base and then to a Base file of 1.18 Mb, which is saved. The Base image is the same resolution as the TV or computer monitor. This shortens the display time. The 4Base image is mathematically reconstructed from the Base image. The original 4Base file and the newly reconstructed 4Base file are compared. The difference is computed. This difference is called a residual and is stored in a compressed format. The same technique is used for the 16Base file. Therefore, by storing only the Base 1.18 Mb file, the residuals, and the lower Base/4 and Base/16 files, you can reconstruct both high resolution images and only require about 6 Mb of storage per image. There is no apparent loss of resolution. Pro Photo CD format can work from a larger original format, to 4 by 5 inches. It produces image components of 64Base, 6144 pixels by 4096 lines.

| Photo CD image components | | |
|---|---|---|
| **Base** | **Pixel resolution** | **File size** |
| Base/16 | 192 pixels by 128 lines | 24,576 K |
| Base/4 | 384 pixels by 256 lines | 98,304 K |
| Base | 768 pixels by 512 lines | 1.18 Mb |
| 4Base | 1536 pixels by 1024 lines | 4.7 Mb |
| 16Base | 3072 pixels by 2048 lines | 18.8 Mb |
| **Pro Photo CD image components** | | |
| 64Base | 6144 pixels by 4096 lines | 72 Mb |

*Figure 21   The five Photo CD and the Pro Photo CD image components and resolutions after image recomposition*

**Choosing a Kodak Photo CD resolution**

Your choice of resolution and file size are determined by the reproduction's enlargement size. Reproductions that are larger than 800 percent may not contain sufficient detail. When making enlargements

of this size, it would be better to use a desktop drum scanner or a highend scanner. Suggested resolutions for different sized reproductions, when the original is a 35 mm transparency, are shown in Figure 22.

| Reproduction size | Resolution | File size |
|-------------------|------------|-----------|
| 1 - 3 inch | Base | 1.18 Mb |
| 4 - 6 inch | 4Base | 4.7 Mb |
| 7 - 10 inch* | 16Base | 18.8 Mb |

\* Larger reproduction sizes are possible using Pro Photo CD.

*Figure 22  Suggested Photo CD resolutions for different sized reproductions, when the original is a 35 mm transparency*

### Kodak Photo CD system advantages

The Kodak Photo CD system allows you to make up pages without having to operate or purchase a color scanner. For a low cost investment, you can purchase a Photo CD ROM drive and computer software that allows you to do your own prepress. The scans are captured directly from your photographs, either negatives or transparencies, and input to a CD ROM. The photofinisher or the service bureau does these scans for only a few dollars each. A disc holds as many as 100 images. You then have many scanned images including the high-resolution images for reproduction, the stored resolution view files and the thumbnail image for file management.

### Separation requirements for printing conditions, original copy and customer desires

Regardless of which scanner you use to capture the images, the separation quality depends on your ability to optimize the color

scans for your printing conditions, the original's characteristics and the desires of the customer. Optimizing the color will require the following adjustments:

- contrast
- color correction
- detail enhancement using unsharp masking
- gray balance
- color balance.

## The importance of contrast for optimum color

*Contrast* is the most important attribute for optimum color. Also called *tone reproduction* or *gradation*, it is the visual tonal relationship between an original image and its reproduction. Contrast is the difference between the whitest white and the blackest black. Each density in the original, from the highlight areas through the middletone areas to the shadow areas, results in a corresponding reproduced density. Big changes between the highlight, middletone and shadow areas result in a "contrasty" reproduction; small changes result in a "flat" reproduction. The relationship can be expressed as a numerical value. The Greek letter $\gamma$ (gamma) represents contrast.

Contrast is influenced significantly by the density range achievable for a given set of printing conditions. *Density range*, also called dynamic range, is the mathematical difference between the lightest and darkest tones as measured with a densitometer. For example, on an original transparency a 0.25 highlight density subtracted from a 3.0 shadow density would result in a 2.75 density range.

Contrast can be shown graphically by plotting the densities of an original on the x axis against the printed (reproduced) densities on the y axis. The slope of this plotted line represents the gamma.

A perfect gamma of 1.0 is a 45° line that represents an exact reproduction of the original image. Any portion of the plotted curve with less than a 45° slope is said to be low contrast. Most often a color reproduction will have normal contrast in the highlights and middletones, and lower contrast in the shadows.

A gamma value is computed by either of two methods. A small triangle drawn on the straight line portion of the plotted gamma curve gives a value for x (run) and for y (rise). The γ value is determined by dividing y by x.

Another method to calculate gamma is to divide the density range of the original ($DR_O$) into the density range of the reproduction ($DR_R$).

$$\gamma = \frac{rise}{run} \text{ or } \frac{DR_R}{DR_O}$$

The highest contrast printed image is possible on coated paper. A glossy surface produces darker shadows and brighter highlights than other paper types. A four-color density of 2.00 is achievable on coated paper printed on sheetfed commercial presses. Coated paper printed web offset using SWOP (Recommended Specifications for Web-Offset Publications), such as magazine publications, produces a density range equal to coated paper printed sheetfed. It is possible to get a 2.0 shadow density on coated paper printed web offset. Subtracting the 0.06 paper highlight density from the 2.00 shadow density, the resulting density range is 1.94.

Using SNAP (Specifications for Non-Heat Advertising Printing) and printing by web offset on newsprint paper, such as your local newspaper, a four-color shadow density of only 1.40 is achievable. Subtracting the 0.20 highlight density of the paper only gives a 1.20 density range. Gravure and flexographic printing have

approximately the same density range as lithography for each paper type.

|               | Transparent Original | Glossy Paper | Uncoated Paper | Newsprint |
|---------------|:---:|:---:|:---:|:---:|
| Highlight     | .20  | .06  | .12  | .20  |
| Shadow        | 3.00 | 2.00 | 1.70 | 1.40 |
| Density Range | 2.80 | 1.94 | 1.58 | 1.20 |

*Figure 23  A comparison of the density range of the original transparency and its reproduction*

The secret to producing good color reproductions is to adjust the tone reproduction to achieve the proper tone compression for a given printing condition and original. *Tone compression* is the reduction of an original's tonal range to one that is achievable using the reproduction process. This is usually necessary, because most original copies' density ranges are greater than that of their printed reproductions. A transparency used as original copy usually has a 2.80 density range from the highlight to the shadow areas. Reflection copy may only have a 2.00 density range, which is closer to the reproduction range. That does not necessarily mean that you will get a better reproduction from reflection copy. How you adjust the tone compression to accommodate the printing condition and original will be the most important factor in achieving good color reproductions.

## Ideal contrast for clean, bright colors

An ideal color reproduction might be an exact copy of the original. When a comparison of each original density to each reproduced density is plotted, the ideal color reproduction's contrast, or tone

reproduction, would be a 45° line if it were drawn on a graph. See Figure 24. However, in actual practice, when the contrast of most reproductions is plotted, it is slightly lower than a 45° line. It looks like the "S" shaped curve in the same illustration. The highlights and shadows are reduced slightly in contrast.

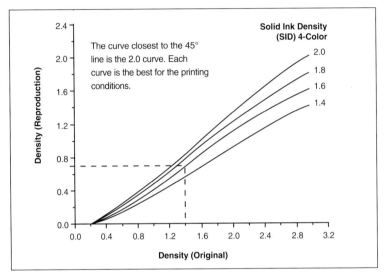

*Figure 24  Tone reproduction plots comparing input and output densities that produce ideal reproductions for different printing conditions*

For each paper and printing process, the exact shape of the ideal tone reproduction curve needs to be determined. Usually the contrast must be adjusted to keep the highlight clean and neutral white, the shadows dark and neutral, and the middletones clean and not too dark.

While observing the image on a color monitor and using appropriate software, you can visually modify the image to achieve the best

possible reproduction for a given set of printing conditions. The highlight, shadow and middletone dot sizes are adjusted. If you were to plot the densities of the resulting gray scales for different printing conditions, you would expect to get one of the curves shown in Figure 25.

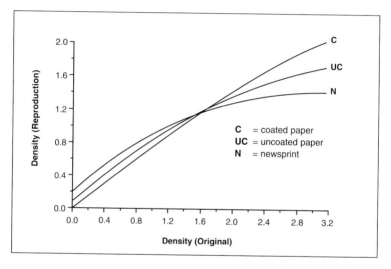

*Figure 25  The relationship between the paper type and the resulting solid ink densities and gray scales produced using the same printing and inking conditions*

*A gray scale* is a tone scale, a strip of gray patches or steps ranging from white to black in either varying densities or varying dot sizes form 0% to 100%. It is used to analyze printing characteristics. It may be made on photographic paper, on a strip of film, on a color proof or printed on paper. On a computer monitor, shades of gray are created by varying the apparent intensity of the screen's pixels, rather than by using a combination of only black-and-white pixels

to produce shading. The densities of the steps represent the densities found in the image.

The paper and ink, dot gain, dot sizes, color correction, the printing sequence, gray balance and unsharp masking (USM) are all variables that affect the printed reproduction. If you understand the effect that each variable has on your results, then it is easier to adjust your separations for the printing conditions, the original characteristics and the customer's desires. In the following sections these variables will all be considered.

### The effect of paper and ink on contrast (tone reproduction)

The effect of paper on the printing contrast is shown on the graph in Figure 25. Densities are compared by plotting the input original's densities along the x axis and the output reproduction's densities on the y axis. When a reproduction is analyzed, every original density is compared to every reproduction density. Analysis of a perfect reproduction results in a 45° straight line. In most cases, printing different solid ink densities (SIDs) results in "S" shaped curved lines for different paper types. Figure 25 illustrates how coated paper (C), uncoated paper (UC) and newsprint (N) affect the contrast.

Reproductions on coated paper have the highest contrast. Reproductions on uncoated paper have lower contrast, and reproductions on newsprint have the lowest contrast. On newsprint, the curve is very flat in the shadows. *Flat* describes low contrast pictures. This descriptive term came from the appearance of this curve. Flat means that either there is little or no difference in shadow densities, or if the original had detail, there's no longer any in the reproduction. Proper adjustment of the density range for different printing conditions produces the best possible contrast and results in a plotted line on the graph that is close to the ideal printed density range curve (see Figure 24.

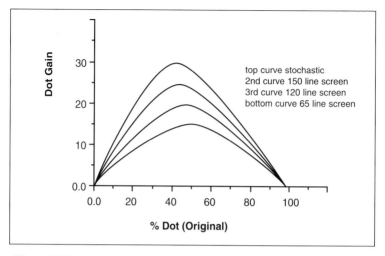

*Figure 26  Isoconture curves showing the typical dot gain from the film to
the printed dots, including the optical dot gain*

### Dot gain and its effect on the reproduction

During the printing process, dot gain is the most important variable
to control. ***Dot gain*** is the increase in the apparent, measured dot size
from the separation film to the printed reproduction. It is the ***physical dot enlargement*** caused by the following reasons:

- plate exposure image spread,
- pressures between the plate blanket and impression cylinder of a
  press, or
- ink spread as it penetrates the paper.

Dot gain is also caused by the ***optical dot enlargement;*** the result of
light trapped around the edge of the dot, referred to as ***border zone***
effect. This causes the middletones to print darker.

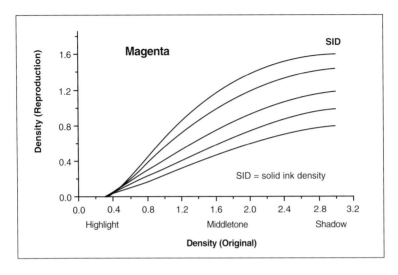

*Figure 27  Graph demonstrating how the middletone densities increase when the ink amount is increased*

The dot gain can be 5% to 35% depending on the amount of ink applied and the kind of paper. Lower quality papers produce higher dot gain. Dot gain causes middletone image darkening because of the apparent dot increase in optical and physical size. Much of the dot gain is an optical gain. Light is trapped under the edges of printed dots. Because of this border zone effect, the dots with the largest circumference gain the most, usually the 50 percent dot sizes. The border zone effect also explains why higher screen rulings have higher dot gain. Higher screen rulings have more dots per inch to grow. There is no way to change this phenomenon. However, to compensate for the problem, the separations are adjusted when they are made. If a 20% dot gain is expected, then the dot sizes on the films are reduced 20% to compensate for what will happen during the printing process.

Isoconture curves were first plotted by Felix Brunner of System Brunner. An isoconture curve such as the one plotted in Figure 26 shows the typical effect of dot gain from the 0 to 100 percent dot size on the film. You will note that the dot gain is greatest in the middletones. Dot gain is measured in the middletone patch, because the majority of dot gain takes place in the middletones. The higher the dot gain, the higher the middletone density is and the dirtier the colors will appear. The dot gain causes increased dot sizes in

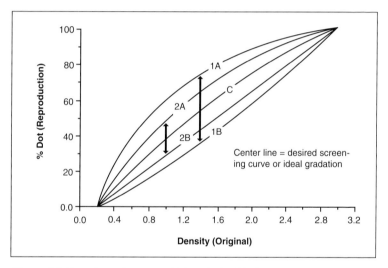

*Figure 28  Two dot gain curves (1A & 2A) with their corresponding middletone reduction (1B & 2B) to produce the ideal gradation (C)*

the wrong colors, making them dull. More dot gain information is found in the PRINTING COLOR section, pages 89 through 101.

On the graph in Figure 27, observe what happens to the curve when the magenta solid ink density (SID), or amount of magenta ink, is increased. As it increases, the shadow density increases. However,

the middletones gain density more quickly than the shadows. This increased middletone dot gain lowers the shadow contrast. This results in a picture that no longer appears clean and attractive. Often such a picture is described as being plugged up. ***Plugged up*** describes the phenomenon of ink printing in the white spaces between the dots. As the dots increase in size, the spaces fill in and the dots begin printing on top of other printed dots. The amount of ink being printed could be reduced. However, enough ink must be printed to achieve the saturated colors.

*Figure 29A  This reproduction was printed on coated paper and appears bright*

*Figure 29B  A simulation of the same image printed on uncoated paper using the same films*

In Figure 28 look at the curve comparing the densities of the original to the reproduction's percent dot area. The center line represents the desired screening curve. The two curves above this line represent how dot gain affects the reproduction's printed dot areas.

*The question is:* **How do you compensate and make the curves more like the desired curve?**

*The answer is:* A more desirable curve is accomplished by reducing the middletone dot sizes. You reduce the middletone dot sizes of the

curve below the center line by an equal amount to that above the center line. When printed, the new plotted line will be more like the desired screening curve. If there will be a 10% dot gain, reduce the middletone by 10%. For a 20% dot gain, reduce the middletone by 20%. Therefore, the secret to good, clean color reproductions is reducing the middletone dot sizes for the printing conditions (the press and paper).

**Halftone screening dot sizes**

Studies have been done to determine the average "fingerprint" of most printing presses. Thousands of presses have been thoroughly analyzed. The studies showed that there is quite a bit of press variation. However, when the industry averages are known, people tend to work toward those averages. Today, the industry aims for the middle of the dot gain variation window. If separations are made that fit that value, the separations will accommodate the given printing conditions. Refer to the information in Figure 30. It shows ideal halftone screening dot sizes for separation films for the three basic printing conditions. These guidelines should produce good reproductions. Whether you are using coated paper sheetfed, coated paper webfed, uncoated paper sheetfed, or newsprint webfed, these are the default settings that you will use to adjust your separations for those printing conditions. Use them for the scanner setup profiles and preferences. The default settings for coated paper webfed and uncoated paper sheetfed are the same. Newsprint is usually printed on a web press.

**Using the densitometer function on your computer monitor**

Critical to your color success is the accurate contrast adjustment of the color separation image. It is not always easy to exactly determine what dot size you have in any image area by looking at the computer's monitor screen. The computer application software

### Coated paper sheetfed

|   | Original | Cyan | Magenta | Yellow | Black | TPPD |
|---|----------|------|---------|--------|-------|------|
| H | 0.30 | 7 | 5 | 5 | 0 | |
| M | 1.30 | 62 | 50 | 50 | 22 | |
| S | 2.90 | 97 | 90 | 90 | 80 | 357% |

### Coated paper webfed or uncoated paper sheetfed

|   | Original | Cyan | Magenta | Yellow | Black | TPPD |
|---|----------|------|---------|--------|-------|------|
| H | 0.30 | 5 | 3 | 3 | 0 | |
| M | 1.30 | 52 | 40 | 40 | 18 | |
| S | 2.90 | 95 | 85 | 85 | 75 | 345% |
| GCR/UCR | | 75 | 65 | 65 | 95 | 300% |

### Newsprint paper webfed (SNAP)

|   | Original | Cyan | Magenta | Yellow | Black | TPPD |
|---|----------|------|---------|--------|-------|------|
| H | 0.30 | 3 | 1 | 1 | 0 | |
| M | 1.30 | 42 | 30 | 30 | 15 | |
| S | 2.90 | 92 | 82 | 82 | 70 | 326% |
| GCR/UCR | | 72 | 62 | 62 | 90 | 286% |

GCR = gray component replacement (see page 71)
UCR = undercolor removal (see page 71)
TPPD = total percent printing dot

*Figure 30  A chart showing ideal halftone screening dot sizes for separation films*

has a densitometer function. By activating this function, you can automatically take dot area readings for each of the four separations. You simply click on any area in the image and the dot sizes appear on the screen. By measuring gray areas in the image, you

**Small highlight dots** do not carry any highlight detail in the diffuse highlight areas. Such dots may be required when printing on darker papers, such as newsprint, because larger highlight dots may dirty up some of the colors.

**Normal highlight dots** put the minimum dot sizes in the diffuse highlight areas, giving neutral white detail. There should be no dots in specular highlights. Dot sizes depend on the paper type. Larger highlight dot sizes are possible on coated paper.

**Large highlight dots** darken the picture and begin to put too much of the wrong colors in the wrong places. If dots are printing in the specular highlights, this is a sign that the highlight dots are too large for the conditions.

*Figure 31  Highlight dot placement*

**Too small shadow dot sizes** lower the reproduction's contrast. The very dark shadows of the original will not reproduce. To adjust for the original's density range, the shadow must be placed in the darkest areas of the picture.

**Normal shadow dot sizes** placed in the correct shadow areas of the original produce a pleasing color reproduction. When the two are compared visually, the reproduction has the same neutral black shadow detail as the original.

**Too large shadow dot sizes** cause too much of all colors to print in the dark areas, and many of the saturated colors may become the wrong color. Placed too close to the highlights, too large shadow dots darken the reproduction and begin to dirty up the colors.

*Figure 32  Shadow dot placement*

can compare the image readings to those you expect for gray balance or for each process color in any part of the tone scale.

The densitometer readings for dot area indicate dot area on the film, not what will be printed. Since all printing conditions are different, you must rely on the dot areas on the films as your reference. Into the color separation application's preferences, you must input the expected dot gain for your chosen printing system. Then, the video display should give you an accurate representation of the expected printed image. If the image appears too dark, then the middletones can be lightened.

With your computer software application, you can also check exact color specifications to determine how any given color hue and strength will appear printed. By making a dot area measurement on the monitor's image, you can compare these results with those given in a color reference, color tint book or fan book. This color comparison technique is called *swatching out* a color. Be sure to use the book's printed swatches on the paper type that matches your paper.

### Adjusting the separation contrast to the copy

The copy is another variation in the separation process. Based on the information in Figure 30, you should set your preferences in the computer for your printing conditions. These settings will produce good separations, provided you fit them to your copy characteristics. Every original copy has unique highlight, shadow and middletone densities. Every original copy also has a particular distribution of the densities between the highlight and shadow, known as its keyness. This density distribution is determined by the copy image content. Some original copy also has an unwanted color cast. You must modify the contrast for the copy's keyness and color casts. These adjustments are important and will most likely determine whether or not you produce a good quality color reproduction.

When adjusting the computer for separation contrast, the *highlight dot placement* is usually the first setting made. After the scanned digital image is imported, you determine where the highlights are in the original image and what the correct highlight dot sizes are for the cyan, magenta, yellow and black separations.

The highlight dot sizes are placed in the *diffuse highlights*. These are the whitest parts of the picture that have detail and are neutral white. Placing the highlight dots in the correct image areas insures that the diffuse highlights are neutral white and will have detail in the reproduction. *Specular highlights*, such as the reflections on silverware or glassware, should not have dots printing in them. If they do, this is a clue that you have misplaced the highlight dots.

Second, the *shadow dot placement* is determined. The shadow dots should be placed in the darkest part of the picture image. The shadow should be a neutral black that has no color.

After the highlight dot placement and shadow dot placement have been determined, you next adjust your *printing density range* to fit your copy density range. This insures that the maximum possible contrast will be achieved. It also minimizes any color cast the copy may have had in the highlight or shadow. The values in the table, Figure 30, produce neutral gray in the highlights, middletones and shadows. The assumption is that if the tone reproduction curves are adjusted properly, the three aim-points will also produce neutral grays in all steps of the gray scale. The mere fact that you place the highlight and shadow according to these guidelines insures neutral grays in all gray areas of the reproduction.

**Sheetfed litho on coated paper** has the lowest percentage dot gain. To compensate for dot gain darkening, the middletone dot sizes are reduced. Typical dot sizes are cyan 62%, magenta and yellow 50%, and black 22%.

**Web offset on coated** or **sheetfed on uncoated** have more dot gain than sheetfed litho on coated paper. Also, to gain shadow detail, the middletones may need to be lightened. Typical middletone dot sizes are cyan 52%, magenta and yellow 40%, and black 18%.

**Web offset on newsprint** gains 25-35%. This dot gain, plus the darker paper, decreases shadow contrast and darkens the color reproduction. Typical middletone dot sizes are cyan 42%, magenta and yellow 30%, and black 15%.

*Figure 33  Middletone dot placement*

## Adjusting the middletone contrast for the copy keyness

Darkening the middletone puts more contrast in the highlight areas and lowers the shadow contrast. The shadows become dark and the contrast flat. Conversely, lightening the middletones will put more contrast in the shadow areas and will flatten out the highlight contrast. By lightening or darkening the middletone portion of the cyan, magenta, yellow and black curves together while keeping the gray balance, the operator can keep the correct color balance, even though the contrast has changed. These middletone changes can be used to add detail in important parts of the reproduction. They also can be used to satisfy customer requests for such things as "open up the shadows," or "clean up the colors."

## Clean and bright or dull and gray

The highlight, shadow and middletone dot placements in the picture determine whether or not you satisfy the customer and get the best possible color reproduction. If the highlight, shadow and middletone dots are not first adjusted correctly, any other adjustments that you make will only produce minor differences. Other modifications will not correct for an improper contrast adjustment. Adjusting the contrast accurately by modifying the highlight, shadow and middletone dots correctly is the most important thing you will do to produce a customer-satisfying, good reproduction.

*The worst mistake that you can make is
putting too much printing dot in the middletones.*

Improper contrast, or tone reproduction, adjustment puts the wrong colors in the wrong places in the reproduction. For example, if too much middletone dot is printing, too much cyan will print in reds, too much magenta in green grass and too much yellow in blue skies. The colors will be dirty. The effect is the same as printing too much black in the colored areas. It darkens the picture and muddies up the colors.

Keeping the middletones where they should be, or a little lighter than they should be, facilitates good color reproductions on press and cleans up colors, making them brighter. When the highlights, shadows and middletones are correct, only minor additional corrections are needed to produce good color reproductions. Makeready is shorter on press. Color OKs are easier. Customers are happier. The printed results are more likely to look like the color proof.

The Scitex Smart™ Scanner, a CCD input device, has built-in algorithms that automatically evaluate the original during a prescan and adjust the highlight, middletone and shadow dot sizes for each original subject for the given printing conditions. This scanner automatically does what highend scanner operators do and what Mac and PC users can do with specialized software. The latest models of highend scanners can also use artificial intelligence to automatically set the highlight and shadow points. If you are not using software on your Mac or PC that adjusts the highlight, middletone and shadow dot sizes for each original subject and the given printing conditions, then you need to take advantage of the graphic arts industry's knowledge about dot size placement and use the correct values in your desktop separations (see Figure 30).

### Color correction

All process inks require color correction. An ideal process ink would absorb only 1/3 and transmit 2/3 of the visible spectrum. The process cyan ink used by most printing processes appears as though it has too much magenta and yellow pigment. As much as a 25% hue error may be present.

Magenta ink also has a serious hue error. Magenta ink appears as though it has too much yellow pigment—sometimes as much as a 45% hue error. The yellow ink is the most pure ink. However, it is contaminated with a small amount of magenta, about 10%. Every

color scanner, or its accompanying software, must somehow compensate for the printing inks.

Looking at the ink appearance representations in Figure 34, you will notice that the extra magenta and yellow make all three inks appear to have orange in them. You compensate for the contaminated inks using the algorithms built into the scanner or computer software. The algorithms selectively reduce the magenta dot sizes where magenta prints with cyan. Printing smaller magenta dot sizes with cyan compensates for the extra magenta contamination already in the cyan ink. This keeps blues from becoming purple. To prevent the reds from being orange, yellow is reduced where it prints with magenta. Also, magenta is slightly decreased in areas where yellow prints.

$$C = C_{+M+Y}$$

$$M = M_{+Y}$$

$$Y = Y_{+M}$$

C = cyan
M = magenta
Y = yellow

*Figure 34  Appearance of inks with the extra magenta and yellow*

The scanner operator may have to fine-tune the color correction software for each ink set. In addition, slight modifications can be made for small ink trapping differences. ***Ink trapping*** is the ability of one wet ink to stick over another wet ink. One hundred percent trapping occurs when the same amount of ink prints on top of the first ink as prints on the unprinted surface. More often, undertrapping occurs. One wet ink will not adhere properly when it is applied over another wet ink. Ink trapping should not be confused with image trapping. ***Image trapping*** is the overlapping of different

color image edges to minimize the effect of misregister and to prevent a white line appearing between two color images during the printing process.

## Printing sequence

The printing sequence affects color quality. Today the most common worldwide printing sequence is cyan, magenta and yellow, with black printed either first or last, KCMY or CMYK. Changing this printing sequence may affect the ink trapping and the amount of color correction needed. The color correction may need fine-tuning by the computer operator. In most cases, color correction is set up as a default condition. Once adjusted, it is left alone.

## Producing gray balance

*Gray balance* is a necessary attribute of good color reproduction. It is reproducing any neutral gray in the original as a gray in the reproduction. The proper amount of cyan, magenta and yellow must print to produce a gray scale with no apparent dominant hue.

To reproduce neutral grays, you must compensate for the ink contamination. The magenta ink and yellow ink dot sizes are reduced throughout the printing scale, in neutral gray areas, from the highlight to the shadow. The most consideration is usually needed in the middletone areas. The dot size values in the Figure 30 chart will produce grays for most printing conditions.

Color scanner color correction algorithms do not automatically correct in gray areas. Therefore, special attention must be paid to reducing the magenta and yellow dot sizes throughout the gray areas of the reproduction. When the original is viewed on the computer monitor and checked with the software's densitometer

function, a neutral gray should always have a smaller magenta and yellow dot size than the cyan dot size. If the three are equal, a brown, rather than a neutral gray, will print. A neutral gray requires that you reduce the amount of magenta and yellow, or add cyan, in that area. Most desktop software programs allow you to fine-tune gray balance by simply adjusting the gradation, so that less magenta and yellow are printing.

## Removing a color cast

A *color cast* is an overall unwanted color tinting of the original copy. It may be predominant in the highlight, shadow or middletone. However, it probably will occur in all the picture content. It may have been caused by exposure, development or a film problem.

Removal of the unwanted cast is accomplished by making changes to the contrast, because it affects all color areas and neutrals. First, you must determine whether the cast is more pronounced in the highlights, middletones or shadows. Then, you ascertain which printer, cyan, magenta or yellow, needs the dot sizes reduced to remove the cast. For example, the highlight might have a pink cast. By reducing the printing dot size in the magenta highlight slightly, the color cast will be removed.

## Using unsharp masking (USM)

*Unsharp masking (USM)* is an old photographic term, describing a method of compensating for a lack of sharpness in the original. The lack of sharpness may be inherent in the original or may be due to the color scanner optics. Using USM, the detail and apparent image sharpness is enhanced. Throughout the picture, the contrast is increased wherever there is an edge between two areas. That might be between a light and a dark, or between one color and another. The

light edge is made lighter than normal and the dark pixels are darkened. This is done in all four printers. It usually puts a little black line around one side of an edge and a light line along the other.

The secret to unsharp masking is adding the right amount to obtain detail, while not making the correction an unwanted visible attribute. The correct amount of unsharp masking is a matter of operator judgment, as well as a function of the size of the final reproduction. A larger reproduction may not need as much unsharp masking as a small reproduction.

When doing digital separations, the software detects an edge by comparing the pixels stored in the picture file. In this case, you can adjust how many pixels wide the effect will be. In addition, you can indicate how much difference there must be before USM takes effect. To produce the best color reproduction detail, some USM is always necessary.

### Separating a very grainy original

When a grainy original is scanned, the scanner may perceive and image the large grain particles. If this happens, some unsharp masking (USM) may be applied to each grain. A drum scanner technique to reduce the graininess is to defocus the image so that the optics do not see the graininess. Although the scanner cannot resolve the graininess, it still can reproduce the color it senses. With the Adobe Photoshop computer program, the despeckle filter is used to remove the graininess.

### Total density vs. total printing dot

*Total density* refers to the total amount of printing dot in a given area on a press sheet or on separation films The term is incorrect,

because the total percent of printing dot should not be specified as a density. The correct term is *total printing dot* .

When printing on paper stock using four process colors, the total amount of dot that can be printed is 400 percent. When normal gray balance is applied, the total amount of printing dot is only 345 percent. SWOP and SNAP recommend that the total printing dot not exceed 300 percent. Gray component replacement (GCR) or undercolor removal (UCR) can be used to reduce the dots sizes to this percentage. See percent total printing dot in Figure 30, page 59.

## Undercolor removal (UCR)

*Undercolor removal* is a technique used to reduce the dot percentages of cyan, magenta and yellow in dark neutral gray areas and increase the black dot sizes to achieve the same neutral gray densities. This reduces the total amount of ink in an area and makes it easier to trap all the layers of ink. Examples of the reduction are given in Figure 30.

## Gray component replacement (GCR)

The *gray component replacement (GCR)* technique reduces the amount of process inks in all colors of a reproduction. The theory is that any color can be made with one or two process inks and a given amount of black to darken that color. The third process color, the smallest dot, only darkens a colored area. With 100 percent of GCR, any color can be reproduced with only two process inks and black. However, in actual practice, 50 percent GCR is normally not exceeded. Therefore, any color will have some of its darkening color removed and replaced with black. For example, a red apple might contain 100% magenta, 80% yellow, 10% cyan and 10% black. Both the cyan and black darken the red and give the apple its shape and detail.

GCR helps keep the colors in control on press and allows the press operator to increase the wanted colors without dirtying the wrong colors. For example, the magenta can be increased without making the blue sky too purple.

## Color separation software packages for the desktop

Color scanners capture the image as digital picture information and download it to the computer RAM memory for additional processing using color separation software. Image capturing programs either acquire the image with the modifications for the printing characteristics and the original on the fly, or they offer the ability to modify the scanned image after scanning. Most separation software does not offer special image retouching functions.

There are many color separation programs available for the desktop computer. Some programs emulate highend scanner functions and require a degree of skill. Others are designed for beginners and can be used to make image modifications without much previous experience. Some give slightly better color images than others. The list contains some currently available color separation programs. The one you select will depend on your scanner and your computer.

> Adobe Photoshop
> Aldus Preprint
> Binucci's Binuscan
> Flamingo Bay's ScanPrep
> Human Software Company's ColorExtreme
> Light Source's Ofoto
> Monaco's MonacoColor
> Optronic's ColorRight 4.0
> Pixel Craft's ColorAccess
> Pre-Press Technologies' Spectre-Print Pro
> Pre-Press Technologies' Colegro

*Figure 35 Illustrations of GCR with the three-color reproduction (top), black reproduction (middle) and four-color reproduction (bottom)*

*Figure 36 Unsharp masking (USM) examples showing increased strength from none (top) to strong USM (bottom). The middle example is most likely the correct USM amount.*

# COLOR PROOFING

The most valuable production quality control tool for reproducing process color is the color proof. It is used to assure that the color separations are made correctly. For a proof to be valuable, it must be calibrated, so that it matches the hues, saturation, brightness and gloss of the printed reproduction. In addition, the color proof must be made in a consistent, controlled manner so we are assured that it is an accurate representation of what will be printed.

## Types of color proofs

There are several times during color production when a color proof is needed. The type of proof used at each production step varies. Any proof made before the contract proof is called a *preproof*.

A *soft proof* is the first proof seen after scanning. The digital image is displayed on the computer monitor screen. Using this image, you can assess how the separations look as you adjust them. Before using the monitor for color separation adjustment, care must be taken to adjust the monitor for white balance and gradation. These need to match the saturation and contrast of the printed reproduction. The monitor can be calibrated to quite accurately represent the final printed reproduction. Too often, people use uncalibrated monitors with bright ambient light (light shining on the screen). This causes desaturated colors, lower contrast and glare. The ambient light in the monitor area should not exceed 10 foot candles. The computer user should also wear a dark neutral shirt so that the light does not reflect from the shirt onto the monitor screen.

A *direct digital color proof (DDCP)* is made from the completed digital files on a printer using colorants on a white substrate to simulate the ink on paper. Several printer types are available, such as ink jet, wax, or thermal transfer. Even though this proof may not contain halftone dots, it simulates the printed reproduction. When the proof is a collection of several individual separation files placed on the page to fill it, the proof is called a *scatter proof* or *random proof.* Some of the more expensive direct digital proofing systems create halftone patterns and simulate the printing conditions.

An *analog color proof* is made on a white, light sensitive substrate by exposing the halftone films made from the digital files to the materials. The dye materials or powders are transferred to the substrate to create a *single-sheet* color proof. If individual mylar layers representing each process color are placed on top of one another over the white substrate, it is called an *overlay proof.*

A *contract proof* is a color proof that is expected to look exactly like the final reproduction. The proof is OK'd by the customer with the expectation that the printing will look exactly like or better than this proof. The press operator diligently tries to adjust the press to match the proof. Usually contract proofs are made with the single-sheet proofing materials because they seem to most closely match the printed result. However, the use of direct digital proofs as contract proofs will increase as they improve in consistency and repeatability.

A *position proof* indicates the accurate positioning of images on a page. It does not accurately match the printing hues. These proofs are made on a lower cost material, such as photographic paper or overlay materials, and are often used to check the final image location before making printing plates.

A *press proof* is made on a printing press using inks and plates to simulate the final reproduction. To be accurate, it has to be printed

on the same press using the same plates and inks that will be used
for the production run. Differences in paper type, press speed and
press type (sheetfed versus webfed, single color or four-color)
affect the results. For years these proofs were state-of-the-art tech-
nology. When a press proof is made in stages, each of the four
individual colors, every combination of colors, a three-color and a
four-color printed result on the white paper, it is called a ***progres-
sive proof*** or ***prog***.

*Figure 37  Single-sheet
color proof*          *Figure 38  Overlay color proof*

### Calibration and control

***Color proofing calibration*** is done by adjusting the exposure and
processing techniques to simulate what will be printed. To do this,
you need a set of negatives and a press sheet from a production job
that was printed under controlled conditions. These are used to
make the adjustments. The film negatives accompanied by special
test targets are exposed. The test targets indicate if any inconsistency
has occurred. The proof is adjusted by modifying the toners, expo-
sure, inks, substrate and processing until the desired color match is
achieved. When the adjusted color proof matches the printed result,

the system is considered calibrated. Once calibrated, a control method is used to insure consistent results.

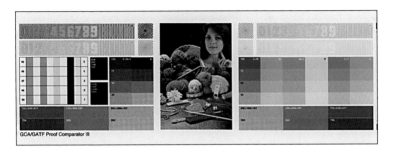

*Figure 39  The GCA/GATF Proof Comparator for determining whether a color proof is made to specifications*

One common calibration device is the *GCA/GATF Proof Comparator*. This device allows you to visually compare the proof to a reference proof to determine if the proof has been made correctly.

It should be pointed out that the color proof and the printing process do not necessarily have to use the same color sequence. Regardless of the color sequence, the proofing only has to visually simulate the color printing. Often, the color proof has the black or cyan as the top color layer.

It is impossible for color separators and service bureaus to match every printer's printing conditions. Therefore, they generally calibrate color proofing to SWOP or SNAP specifications. (See Color control specifications and references, page 106.)

Viewing color proofs must be done using standard 5000K lighting conditions. Some proofing materials are **metameric**, which means that they appear differently under different lighting conditions. For

accuracy, the color proof and the original or the press sheet are viewed side by side under standard illumination. The press sheet is folded and laid on the original or OK'd proof, so that the same areas are in contact with one another. A person's eyes are very good at making side by side color comparisons of color images. Because we do not have a good color memory, we cannot hold the proof in one hand and the press sheet in the other, and expect to confirm a color match.

Uncalibrated color proofing causes the most waste, spoilage and remakes in the printing industry. Incorrect separations are accepted, when pretty white-and-bright proofs that do not simulate the substrate or dot gain are made from separations. The printing will not match the proof, and the customer will not be happy with the printed results.

### Calibrating your color monitor

As a first step to achieving good color reproductions, the digital separation files are displayed on the color monitor and adjusted. Therefore, you must have confidence that the monitor display is accurate and calibrated.

Color monitors are calibrated by visually comparing an image on the screen with the color reproduction of the same image. For the most accurate visual comparison, the reproduced image is placed in a soft proof viewing booth that is located immediately next to the video monitor. *A **soft proof viewing booth*** has 5000 degrees Kelvin (5000K) illumination with adjustable intensity. This makes it possible to match the monitor and viewing box's light strength. The image on the screen is evaluated and the monitor is adjusted until the two images match.

You should follow these color monitor calibration steps:

1. Obtain a printed reproduction of a picture file and the digital file.
2. Place the printed reproduction in the color viewing booth.
3. Place the viewing booth beside the monitor and adjust its light intensity to match the monitor's screen light intensity.
4. Compare the reproduction on the monitor screen with the printed sample in the viewing booth visually, side by side.
5. Set the color monitor's color temperature (the white point in degrees Kelvin) using the software profiles or preferences. It may be possible to use special color probes and software to accurately calibrate the video monitor color temperatures.
6. Adjust the color monitor's gamma correction for contrast, saturation and brightness so that the monitor image matches the printed reproduction. The gamma correction does what some people misinterpret as color correction, because it changes the middletones and "cleans up" the picture.
7. Leave the settings unaltered between calibration sessions.
8. Tape over the monitor controls to avoid any accidental changes.

**The effect of ambient lighting conditions on monitor accuracy**

Lighting conditions must be considered when the monitor is being set up for color image evaluation. The existing light present on all sides of the monitor display, greatly influences the image's visual appearance. The surrounding light near the monitor should be about ten foot-candle illumination. This is very dark. The monitor should be shielded so that no light shines directly on the monitor screen. Rather, soft indirect light should shine on the ceiling. The operator should wear a dark neutral blouse or shirt to eliminate reflections on the monitor screen.

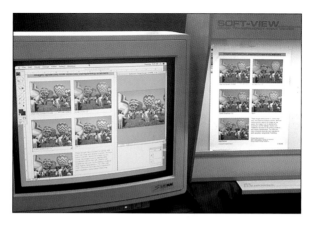

*Figure 40  Calibrating your monitor by visually comparing side by side an image on the screen with the color reproduction of the same image in a standard viewer*

## Color management systems (CMS)

If you are working with a desktop color system, you need to have confidence that all the system parts are calibrated and accurate. You want certainty that what you see at each stage of production looks exactly like the final reproduction—commonly referred to as "What You See Is What You Get" (WYSIWYG).

Color management systems (CMS) are software algorithms and, sometimes, boards. They make it possible to characterize each peripheral device and readjust its color space. The process of aligning the color space of one device with that of another, using algorithms or look-up tables is called *gamut mapping*. This insures that an image from each peripheral device matches the final output for color and brightness. Input scanners, video monitors and digital color proofers can be characterized and calibrated with gamut mapping for specific printing conditions. Eventually CMSs will be included with all peripheral devices.

# PAGE MAKEUP

Once the color separations are determined to be correct for color and size, they can be saved and imported into a document or page. On the desktop, saving files in an encapsulated PostScript (EPS) format seems to facilitate importing them into a page makeup program, such as QuarkXPress or Aldus PageMaker. Some operators prefer to use TIFF (tagged image file format). Saving the files as DCS (desktop color separation) files slightly speeds up the digital proofing. For proprietary CEPS systems, those with exclusive design and software, the files are saved in their native formats. All color correction, resizing and modifications should be made before importing files into the page.

Page makeup programs are used to place all images on a page in their correct positions and file formats for output. Text, graphics, line images and halftone images are placed and adjusted for their size, color, strength, fonts, style, etc. All crop, trim and register marks are also placed on the page. All the page makeup functions that used to be performed by the mechanical artist or the film stripper can now be done on the desktop computer.

### Color image trapping

Often color images on a page meet each other causing a line to occur between the two different colors. If they meet exactly, there is no problem. However, most printing presses allow the page register to vary slightly as the sheet passes through the press. If one color moves away from another, an objectionable white gap is created. To prevent this from happening, it is customary to overlap the two images by one or two rows of dots. Then a misregister on the press will not cause the white line.

Trapping is done by overlapping images, one image is made larger and one image smaller. Strippers used to do this by making film "spreads and chokes" or "fatties and skinnies." Now it is done with software during or after the page is made up. Trapping can be done within an application such as FreeHand, Illustrator, PageMaker 5.0 and QuarkXPress. Trapping software is available such as Aldus TrapWise, Island Graphics' IslandTrapper, Rampage's TrapIt and Scitex's Full Auto-Frames.

## Imposition software

*Imposition* is the correct positioning of publication pages on a large press sheet so that when the press sheet is folded to form a signature, the pages are in the correct numerical sequence. A *signature* is a printed, folded press sheet that when trimmed and bound becomes a section of a publication. Eight-page, sixteen-page and thirty-two page signatures are common.

Before outputting films on the imagesetter or film plotter, all the images must be placed in their correct position for printing. Image placement for proper printing should be done by the printer, or by the person responsible for the film output. To do this, the operator needs to know all the attributes, such as the plate size, press size, paper size, trim, creep, gripper bite, plate bend and finishing steps. If the imposition is correct, very little film preparation will be necessary for platemaking. Imposition can be done with appropriate software, such as Aldus' PressWise, Island Graphics' Imposition Publisher, ScenicSoft Preps, Ultimate Technographic's Impostrip and QuarkXPress extensions (Printer's Spreads, INposition Lite and INposition).

It is also common for printers to use a step-and-repeat platemaker for plate exposure. This device takes each image, regardless of whether it's a page, label or folding carton, and places it in its correct position on the plate. The introduction of large film format output may reduce the need for step-and-repeat platemakers.

# SEPARATION OUTPUT

Separation output must be appropriate for the printing process, the image carrier (the plate or cylinder) and the platemaking device. If films are needed, they are exposed on a scanner film plotter, a CEPS, or an imagesetter. Direct-to-plate materials make it possible to image the complete plate in an imagesetter made especially for plates. This eliminates the need for film output. In 1994, direct-to-plate materials are not yet well developed; their future use will no doubt increase.

Gravure cylinders are being electronically engraved direct from the digital images in the files. Older engraving machines require reflection prints, called bromides, or film from which to engrave.

Flexography can use either films for platemaking or a direct plate engraving machine. It requires TIFF digital files.

### Imagesetter

An imagesetter, the most popular output device for desktop page makeup and color separations, is a peripheral device designed to expose images on film. The imagesetter converts digitally stored page or separation information from file format to film format. The text, graphics, black and white halftones, and color separations are output on the film. The imagesetter exposes the film line-by-line either on a drum or between rollers, called a *capstan*. Of the two methods, drum imagesetters are considered to be more accurate.

## Imagesetter/film plotter calibration

Good color separations require highly accurate output devices. It is imperative that the imagesetter or film plotter operator calibrate the device precisely. Good results can only be assured when every file dot size from 0 to 100 percent reproduces on the film from 0 to 100 percent, respectively, within ± one percent accuracy. Calibration software is available to calibrate the imagesetter or film plotter for accurate dot sizes on the film.

The *RIP* (raster image processor) is a software program and/or board and computer. It determines what value each pixel of a final output page bitmap should have based on commands from the page description language. *PostScript* is the most popular page output description language.

Today imagesetters are capable of producing films without undesirable artifacts, such as moiré, image size problems, banding or fit difficulties. Halftone dots should change in size from 0 to 100 percent with a smooth gradation. *Banding* occurs when the gradation is interrupted by strips of greater or less than desired dot sizes. It is caused by irregular film motion within the imagesetter. The stripes of irregular density run perpendicular to the direction of travel. *Fit* refers to maintaining the exact distances between images on the films. Fit and register are not synonyms. Register is explained on page 91.

## Halftone screen rulings

High screen frequencies, screen rulings above 133 lines per inch (lpi), minimize visible moiré and increase the detail. However, they increase the dot gain considerably. The SWOP standard calls for screening at 133 lpi for magazines. Some printers use 175 and 200 lpi routinely for commercial work. Screen rulings over 200 lpi do not

noticeably improve sharpness. When you increase the screen ruling above 150 lpi, the dot gain increases dramatically.

*Figure 41 133 line screen ruling (SWOP)*

*Figure 42 200 line screen ruling*

*Figure 43 Stochastic screening*

**Halftone screening**

*Software screening algorithms* are available in some page makeup software programs. Halftone screening algorithms are resident in the imagesetter RIP and may be overridden by a screening algorithm in the page makeup program. Usually the screening algorithm resident in the RIP produces halftones by varying the dot sizes from 0 to 100 percent at the correct angles and screen ruling frequency to eliminate any objectionable moiré patterns. Screening algorithms resident in the RIP seem to do a better job than those in page makeup programs.

*Regular, rational and irrational halftone screen grids* are symmetrical patterns of dot rows and columns, all placed in an exact, evenly spaced pattern. When more than one halftone grid is placed over another, the angle of the grid must be rotated 30° to eliminate a moiré pattern. Three screens rotated at 30° total 90°. This leaves no place for the fourth screen pattern. It is standard practice to place the three strong colors, cyan, magenta and black, at 30° apart and the yellow at either 15°, or at the same

angle as the cyan. Because imagesetters use mathematical models to create the halftone dot angles and spacing, it is common practice to slightly vary the dot screen angles and the spacing for each color. A typical set of halftones might be as follows:

|         | **Angle** |
|---------|-----------|
| cyan    | 105°      |
| magenta | 75°       |
| yellow  | 90°       |
| black   | 45°       |

Tangents are used to compute the angle. The screen rulings are referred to as *rational* when their tangent is a whole number and *irrational* when the tangent is not a whole number.

***Stochastic halftone screening*** and other screening methods are gaining in popularity. Stochastic halftone screening uses algorithms to achieve differing tonal values. The dots are very small and all the same size. Random frequency modulated patterns change the number of dots in a given area. One definition given by Mills Davis states that the pattern is not truly random, but rather is adjusted to fit the image in each pixel analyzed. Agfa's Level 2 CristalRaster changes both the screen frequency and dot sizes. Unique screen patterns are available from the following companies:

| | |
|---|---|
| Adobe | Brilliant Screens |
| Agfa | CristalRaster |
| American Color | Megadot |
| Barco | Monet Screens |
| DuPont-Crosfield | Crosfield Lazel |
| Harlequin | ScriptWise |
| Hyphen | Stochastic screening |
| Isis | ICEfields |

| | |
|---|---|
| Linotype-Hell | Diamond |
| Prepress Solutions | ESCOR |
| R.R. Donnelley | Accutone |
| Scangraphic | High-Fidelity stochastic |
| Scitex | Scitex Class screening |
| | Fulltone |
| | Geometric dot |
| | High definition |
| Screen USA | Multi-Screening |
| SeeColor | Clear |
| Tegra-Varityper | ESCOR II |
| TransCal | HiLine |
| UGRA | Velvet screening |
| 5D Solutions | Stochastic screening |

These new screening patterns tend to produce more detail, because many dots print in intricate areas. The bad news is: these screening patterns produce about 10 percent more dot gain than conventional screen patterns. This means that the middletone curves have to be adjusted to compensate for the added dot gain. See Dot gain and its effect on the reproduction, page 54.

*Hi-fi printing* utilizes a combination of extra color separations, stochastic screening and regular printing. It increases the color gamut and detail more than conventional four-color process printing. DuPont's process adds a second cyan, magenta and yellow at higher screen frequencies to accomplish the same purpose.

# PLATEMAKING

Making accurate plates for most printing processes is not difficult with today's technology and control devices. Offset platemaking exposure levels must be optimized to maintain the exact dot sizes from the film to the plate. Errors in plate exposures can increase dot gain on negative plates and *sharpen* positive working plates, which means the dots are made smaller.

Control strips with microlines and step tablets allow you to expose and process printing plates so that they hold very small dots consistently. Variation in plate exposures can have a detrimental effect on color quality, especially when exposing the very small highlight dots that make up the stochastic halftone screen patterns.

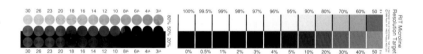

*Figure 44  The RIT Microline Resolution Target*

# PRINTING COLOR

Controlling color printing is just as important as controlling the color separations. You may need to be at the printing press certifying that the printing is being done correctly. Your concerns in order of importance are as follows:

1. Does the color printing match the OK color proof for color hues, overall color balance, contrast and strength?
2. Are the images in exact register?
3. Are there unwanted objectionable attributes, such as hickeys, scratches, smudges, moiré, slurring, doubling or ghosting?

Throughout the pressrun the color OK proof or the color OK press sheet should be kept handy for side by side comparison with each

*Figure 45  Examples of one kind of cyan and magenta ink printed on several different kinds of paper. Notice the differences in hue and saturation.*

new press sheet being checked. Once a color OK press sheet is achieved, it is probably a better color reference than the OK proof. To maintain the match of the OK press sheet and the new color sheets taken from the press, the hue accuracy must be sustained. This should be done, even if ink levels have to be adjusted separately. Consistent hue throughout the pressrun is the most important criteria for good color reproduction. This also requires that color balance be maintained. For packaging and labels, the color must match the reference and the previous pressrun.

## Maintaining color balance

Maintaining the color balance of the overprint colors also helps to produce consistent hues. *Overprint colors* are made by overprinting any two process inks to form blues, greens and reds. A change in their color strength is not as serious as a shift in their hue, such as from red to orange.

The press sheet comparison should only be executed under standard 5000K illumination. Non-standard illumination will modify how the colors appear. This could incorrectly influence your decision about ink strength.

## Solid ink density

The greatest influence on the amount of dot gain is solid ink density (SID). It is the amount of ink applied to the paper.

The printing characteristics will determine what solid ink densities can be printed on a given paper with a given printing order and a given set of printing conditions. Solid ink densities must be adjusted for each process ink color so that any two inks can be combined to produce good red, green and blue overprint colors.

The overprint colors must have the proper and saturation. Too much ink causes excessive dot gain and fill-in, plugs the shadows, and consumes ink. Low ink density causes weak colors and a washed-out appearance because it weakens the saturated and overprint colors.

Solid ink densities are not established to produce gray balance. They are determined by what produces good overprint colors. Optimum SID gives the highest possible contrast without flattening the shadow contrast. SID can be varied on press to maintain a consistent color hue and color strength. On page 53, there is discussion about different SIDs for different paper types: The effect of paper and ink on contrast (tone reproduction). Figure 25 shows the relationship between the paper type and the resulting solid ink densities and gray scales produced using the same printing and inking conditions.

## Identifying color printing problems

*Register* means that color images line up exactly, and that one color does not hang outside another. It is important to certify that all colors are kept in register within ± one row of dots. This is generally considered acceptable register. Variation of two rows of dots is noticeable. Variation of three rows of dots is objectionable and probably not acceptable. Fit and register are not synonyms. Fit may be caused by a paper problem, see Identifying paper problems, page 94.

*Sharpening* is called negative dot gain. It is usually encountered when positive films are overexposed, or when positive working plates are made using positive transparencies. This phenomenon can be used to advantage when halftone dot sizes need to be reduced.

*Crossover problems* may occur when a colored image covers two pages in a book or magazine. The image is called a crossover because

it spans the binding edge. When the book is assembled, both parts of the picture may not line up, or the color may not match on both pages. Problems occur when the picture is printed on two different signatures or two different types of paper. Sometimes it is necessary to make modification in the halftones for each picture portion, so that the color matches. When you plan the job, if you do not understand the requirements and limitations of book binding processes and equipment, it is important to work with someone who does. Otherwise, a well printed color job may end up looking like a disaster after binding.

*Dot gain*, the apparent dot size increase from the film to the printed reproduction, was described on page 54, Dot gain and its effect on the reproduction. Dot gain can be simulated on a video monitor by adjusting the white point and gamma (contrast).

Dot gain resulting from the physical dot enlargement is either caused by a mechanical press problem, or by ink spread as it penetrates the paper. Factors affecting dot gain are paper type, ink type and solid ink density. Types of physical dot gain include slur, doubling, fill-in and plugging. Optical enlargement of the dot is caused by rough or textured paper surfaces and finer screen rulings.

*Slur* is the smearing of the halftone dots on the press sheet in the direction of travel through the press. The dots have tails, look like comets and cause dot gain.

*Doubling* is a condition that causes a second dot set to print between the desired set of dots on a press sheet halftone image. Usually this second set is weaker. Its effect is to add density to the press sheet and cause the picture to darken or have a color cast. Doubling is caused by a mechanical problem with the press, such as loose blankets, improper paper transfer, or improper cylinder packing.

*Fill-in* and *plugging* are two terms indicating a type of dot gain. While often interchanged, *fill-in* usually indicates dot gain in the

middletones, and *plugging* occurs when the non-printing areas between the dots of the shadows are filled with ink and print as solids.

**In-line problems** occur on a lithographic press when colored press sheet images that fall directly behind one another are not color balanced one to the other. It may be necessary to modify the fountain key ink setting to correct one color in one direction on one image. The problem is exaggerated when another reproduction in the same position needs a color change in the opposite direction. For example, if one color reproduction needs heavy magenta and another needs light magenta. These potential inking differences should be detected while evaluating the color proofs. Then, the films can be modified at the digital stage, so that the reproductions are better balanced one to the other. Only balanced images can be printed in-line on the press sheet. In-line problems cannot be corrected on any press.

**Hickeys** are small voids in the printed image caused by contaminated ink or contamination on the paper's surface. The unwanted material is picked up by the plate or blanket. Where it meets the paper, no ink is transferred.

**Ghosting** is a weak image directly behind a heavy image area. During printing, the rollers deposit most of the ink in the heavy solids. The area behind the heavy solid is starved for ink. Ghosting problems vary with presses; some of their inking systems are better than others. Ghosting can be minimized by carefully designing printed work.

**Moiré** is an objectionable pattern usually attributed to improper screen angles. However, it can be the result of certain press conditions. Press slipping or slurring causes moiré. This could show up on the reproduction, but would not be visible on the color proof. The press control bars may indicate which variable is causing the problem. See Produce the halftones on page 11 and Figure 7, page 12.

*Scumming* is a weak buildup of ink on the printing plate, caused by an improper ink/water balance. This leads to dot gain, because a weak ink film prints between the dots.

## Identifying paper problems

Paper problems are obvious defects on the printed paper surface that relate to the interaction between the paper and ink. While the paper may not be at fault, the problem appears on the printed paper surface. When choosing the paper for a job, the buyer must consider such things as the final use of the reproduction, the desired appearance, the readability, etc. After determining the desired result, the following attributes must be considered:

- paper grain
- finish
- strength
- moisture content
- dirt
- affinity for ink
- opacity.

These attributes can cause printing problems, such as stretch, fiber puff, blistering, picking, chalking and setoff.

*Stretch* is the distortion of the paper size. It usually occurs against the grain when the paper is under tension. The cross-grain direction expands and contracts as the paper responds to moisture, temperature and pressure. Stretching causes *register* and *fit* problems. The paper grain is the direction of the fibers that correspond to the direction the paper was made. Paper responds the best when it goes through the press in a cross-grain direction.

*Fiber puff* is a swelling of certain fibers in the paper. This causes noticeable change in the paper surface due to the moisture content. The surface roughens. The reproduction's color saturation may become less, and the images may misregister.

*Blistering* is another problem related to paper moisture content. Moisture is trapped under the ink during the drying process. Small bubbles form in the dried ink. This is most apt to occur when the paper is heated in a dryer. When the blister flakes off the paper, there is a void in the printed image.

*Picking* is a void in the printed image caused by a weak paper surface. The paper is visible in a small area in the image. Picking usually occurs when the tack of the ink is greater than the strength of the paper surface. A part of the image and paper surface is pulled off the sheet by the ink. In waterless lithography, it may be caused by ink that is too cold.

*Chalking* may also appear as a void in the printed image. The printed dry ink can be wiped off the printed sheet. This problem may be related to the paper's affinity for ink and the drying process. The ink may have dried too rapidly.

*Setoff* is a wet ink problem. The wet ink is rubbed off the press sheet and causes smudges on the reproduction or marks on the back side of the next sheet. Setoff is related to the paper's affinity for ink and to the drying process.

*Bleed through* occurs when the printed image on the reverse side of the press sheet, or the printed image on the sheet below, is visible through the paper. It is related to the paper's opacity and can be an objectionable printing defect.

*Fit* refers to maintaining the exact distances between images on the films. Change in paper size as it travels through the printing press

will cause fit problems. The change in paper size may be the result of its being heated and cooled, stretched and shrunk, or wet and dried. The size change between printing units may be the result of improper packing. Good fit is achieved when the distances between images on each film or plate are maintained. If the images are not overprinted correctly, it is possible to have good fit and still have misregister, or the reverse may also be true.

*Fan out* is the increase in the paper width on the tail edge of the sheetfed press sheet. This causes image distortion. It is possible for the press operator to add devices to the press to pull the tail edge of the sheet in to make the images fit for each color.

*Brightness, smoothness* and *absorption problems* can be detected quickly with a visual comparison of a sample of the paper received with samples of the paper ordered, or with samples of previous pressruns. The paper differences from the sheet's felt side to the wire side are caused by the Fourdrinier machines that makes the paper. Even paper made on the new twin wire machines has some variation from side to side. The differences relate to the way paper is formed and dried and are more noticeable on uncoated grades than on coated grades.

*Mottle* is little spots of graininess caused by an incompatibility of the ink and paper. In waterless lithography, it may be caused by ink that is too cold. Brightness, smoothness, absorption and mottle can be tested with a simple *drawdown test*. The ink is wiped across the paper and the reaction is observed visually.

*Textured paper surfaces* can cause problems, such as optical dot gain. It occurs when light that should reflect off the surface of the paper is trapped under the edge of the dots. See Dot gain and its effect on the reproduction, page 54.

## Ink characteristics

*Ink hue* is its specific color. The *ink strength* or *tinctorial strength* is the relationship between the amount of pigment and the amount of vehicle. The ink's color hue and strength characteristics can be checked by comparing the ink to a standard or to the printer's current ink using a simple drawdown. The ink's color hue, strength and grayness can be measured with a densitometer with each color's complementary filter and compared to the standard or current ink readings. The complementary filters for process inks are the red filter for cyan ink, green filter for magenta ink and blue filter for yellow ink.

It is important to have consistent ink hues because process ink hues are impure colors. As a result, all color halftone separations require color correction. If the separator is to have confidence that the corrections made in the separations will print properly, the ink hues must be consistent. Process cyan ink appears to have too much magenta and yellow pigment. As much as a 25% hue error may be present. Magenta inks also have a serious hue error. Yellow process ink is the most pure. For more information about hue error adjustments, see Color correction on page 66.

*Tack* is the stickiness of an ink. *Stability* refers to its ability to maintain constant tack over time. Devices that simulate the rotating forces of a press are available to measure ink tack. It is tested over a time period with a given ink amount. The result is a prediction of how the ink will function over a similar time on press. In multicolor printing, a tack sequence should be established for proper trapping. The first color down should have the highest tack; the next color should have the second highest and so on.

Numbers are assigned to rate tack. Generally the relationships between the tack number and the paper grade are as follows. Low tack inks (5-7) are used with newsprint. Medium tack inks (9-14) are

used with magazine coated groundwood papers. High tack inks (12-16) are used with good coated offset papers printed sheetfed.

Ink tack affects dot gain. Less dot gain will occur with high ink tack. Inks with too high tack may pull the paper surface off. Therefore, an ink tack compromise is necessary to prevent dot gain and picking.

*Viscosity* is a property of fluids resulting from molecular attraction, which makes them offer a resistance to flow. Viscosity and tack do not necessarily operate together. That is, a high tack ink may not be highly viscous. Both viscosity and tack may affect dot gain. Viscosity is an important property in trapping and in the behavior of the ink on distribution rollers. While high viscosity ink might run at 86-104°F, low viscosity inks used in waterless lithography usually run at 68-86°F.

*Fineness of grind* and *pigment dispersion* cause problems from ink batch to ink batch. Often the pigments are not ground uniformly, or the grinding methods change. The grind is judged visually by observing the ink for smoothness or scratches.

*Ink absorption* and *gloss* are tested with a drawdown test. The ink is examined before and after drying. Ink absorption can be determined with a brightness meter reading. One reading is taken of the paper with no ink and another reading is taken after the ink has been applied. As the brightness drops, the absorbency of the paper/ink combination increases.

## Identifying ink problems

The process ink quality definitely affects the printed results. If it's hue and strength, tack and stability, pigment and viscosity are not consistent, the image color may vary across the picture or

from press sheet to press sheet. The image may be too dark or too light. There may be pigment spots or scratches in the image.

*Trapping* is the ability of one ink to print on top of another wet ink. If the ink tack is incorrect, the second ink may not transfer properly. If there is too much total dot percentage printing in an area, the top ink may not transfer. That is why SWOP specifies a maximum 300 percent printing dot for publications. Poor trapping will cause color shifts to take place. For example, if magenta prints over yellow and it traps poorly, a red apple could turn orange. This is a good reason to print yellow on top of magenta. One benefit of the gravure printing process is that the inks dry between printing units. Therefore, undertrapping is seldom a problem. Ink trapping is controlled by adjusting ink tack.

*Ink-water imbalance* can cause dot gain during the pressrun. The ink-water balance can change and cause the plate to scum or tint, and print a weak ink film between the dots. The printing begins to appears too dark and dirty. Too much water can cause a weak image. This imbalance is difficult to detect unless you examine the sharpness guides on the control patches. Waterless lithography does not have this problem.

*Toning* occurs when all nonimage areas between the dots begin to print a weak color that gives the visual appearance of more color everywhere. This may be caused by ink-water imbalance or plate scumming.

## Correcting printing problems

*Dot etching*, *wet etching*, *flat etching* and *dry etching* were manual techniques used to alter the percent dot of each color halftone film in order to change hues in specific areas of the color reproduction. Today, dot sizes are adjusted digitally with computer software before the separation films are made.

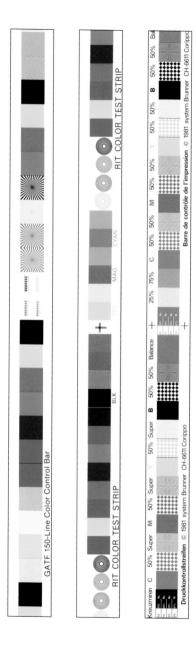

*Figure 46  Example of press control strips available form Graphic Arts Technical Foundation, Rochester Institute of Technology and System Brunner*

## Doing a press OK

In the printing industry, it is standard practice to have the customer approve a printed sheet on-site. It is usually assumed that the customer expects the printed result to match or exceed the color proof.

When the customer is happy, s/he signs the press sheet, marks it OK and dates it. From that point on, for the rest of the pressrun, the press operator will use this OK press sheet as a color reference for controlling the color.

When doing a color OK, the following desirable attributes should be confirmed:

- The ink colors and overprint colors match the proof.
- The dots are printing clean and sharp.
- All the color printers are in exact register.
- The gloss of the inks is as desired.
- There are no unwanted attributes such as moiré, scratches, ghosting, roller marks, slurring, doubling, setoff, wrinkles, or hickeys.
- The color strength is accurate.

Once the color OK is made, the press operator must control the press and keep the printed press sheets identical to the OK press sheet.

When making all visual evaluations, the proof or OK press sheet and fresh press sheets should always be placed side by side in standard 5000K viewing conditions. The OK press sheet is folded so that the most critical parts can be placed directly over the same points on the press sheet being checked for consistency. Always compare, do not try to control color from memory.

*Drydown* is the phenomena where a wet ink will lose a little gloss and density when it dries. If the ink is slightly dark when wet, it may dry lighter. A rule of thumb is: expect about a -0.10 decrease in density when ink drys.

# PRESS SHEET CONTROL DEVICES

## Color control on the printing unit or press

Control devices or test targets are often printed on the tail end of a press sheet to help the press operator optimize and control the press, and identify problems. The test strip targets are designed to be more sensitive to the printing variables than the halftone screens being printed. This makes it possible to determine a change in the printing conditions before a major problem is noticeable on the press sheet. These strips are then trimmed off the sheets before finishing.

Color control strips for lithography are available from FOGRA, Graphic Arts Technical Foundation (GATF), Graphic Communications Association (GCA), GRETAG, Rochester Institute of Technology (RIT) Technical and Education (T&E) Center, System Brunner, The Japan Printing Academy and UGRA. Each control strip consists of patches that represent elements found in the printing, such as solids, tints, overprint solids and tints, individual color scales, three-color gray scales, dot gain and slur targets, and plate exposure targets.

The control strip, printed in the trim area of the press sheet, is compared with the same targets on the OK press sheet. The evaluation/comparison can either be done visually or with densitometer readings, or both methods can be used. With a densitometer, the test targets on each can be measured and the readings compared.

## Color accuracy and hue consistency

Color accuracy and hue consistency can be checked utilizing the overprint patches on the test target for both solids and tints. When a change is noticed, the press operator uses the other test target patches to determine which variable is changing and causing the hue variation.

The printing factors indicated on most color control strips are dot gain, slur, doubling, sharpening, fill-in, and trapping. By identifying the problem, the press operator can eliminate the color variation source.

Color control strips contain three-color overprinting patches of different screen values designed to produce neutral gray patches under average printing conditions. The patches are usually situated next to a black tint patch of nearly the same density value. The press operator visually evaluates the three-color patch next to the black patch. The two patches can also be compared with a densitometer. The gray patch is made of tints of all three process inks. Therefore, it is a good indicator of what is happening in the printed images. When a gray patch changes to a color or has a color cast, chances are the entire reproduction is changing in that direction. The press operator has to decide which way the color is changing, and whether it is lighter or darker than the black patch. Then, the press operator determines which ink has to be increased or decreased to reestablish a neutral gray. Press operators are attuned to looking for color shifts, and the gray scale patches are very sensitive to any changes in the printing conditions.

Control strips use microline targets to indicate when printing factors such as doubling, dot gain or slur are taking place. The press operator can tell at a glance what is happening by observing the microlines and noting the pattern that develops.

Figure 47  SWOP Booklet

Figure 48  SNAP Booklet

Figure 49  GCA T-Ref

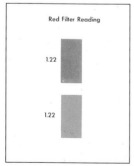

Figure 50  Color patches of differ-
ent hues that measure the same
using a densitometer

Figure 51  A typical
densitometer

Control strips can be analyzed by taking densitometer measurements. To make the evaluation process quick and painless, there are scanning densitometers to read the control strips and develop a statistical analysis about the pressrun. Scanning densitometers can even compare the OK press sheet and the color proof or the last pressrun of the same job. They read the entire strip in about 10 seconds. This eliminates the press operator's excuse that there isn't enough time to take many densitometer readings. Scanning densitometers are available from from X-Rite, Tobias and other companies.

### Densitometers and colorimeters

The densitometer is the most used color control instrument in the graphic arts. Today's densitometers are accurate and dependable. They not only read density, they can measure and compute almost all variable values, such as dot gain, trapping, print contrast, hue error and gray.

*A word of caution is in order.* A densitometer was originally designed to measure a process ink through a complementary filter and determine the amount of that ink present. This reading indicates the relative amount of ink being applied. A single-filter measurement does not verify the ink color. It takes a more sophisticated, more expensive instrument, a colorimeter, to accurately measure color. It measures a color and computes its hue and saturation in color space as number values. The colorimeter is more appropriate than a densitometer for color consistency control on a color press. See Color measurements, page 20.

Each ink is measured separately with a densitometer. It is assumed that if each color is independently controlled, there will be no color variation. In actual practice, a better indication that the printing conditions are varying is a change in the gray patch.

A densitometer must be calibrated to a standard. The *GCA T-Ref* is an ink-on-paper color reference. It has been calibrated on a reference instrument. You should use it to check your instrument's calibration as well. After instrument calibration, you should be able to communicate your measurements with anyone who is trying to control a pressrun of the same or similar product.

## Color control specifications and references

The magazine publishing industry was one of the first to realize it had a serious color consistency problem. Magazine advertisements needed to appear the same in all publications. However, printers couldn't print some films. Trade shops didn't know how to accommodate for varied printing conditions. To eliminate these problems the magazine industry gradually formulated and refined a series of recommendations. Today these are known as **SWOP** (Recommended Specifications for Web-Offset Publications). They are for magazine ad color proofing. These specifications help separators and advertising agencies certify that the halftone films and color proofs are made to industry's specifications. Therefore, they should print without difficulty on the production run. When separations are made to these specifications, what you see on the color proof will actually be what you see on the printing.

Other countries also established specifications for magazine advertising. Those are the Magazine Advertising of Canada (MAC), Eurostandard, and FIPP (International Federation of Publishers Press). These magazine ad specifications are remarkably similar to one another.

Newspaper color advertising had similar problems with its color ads. This industry established **SNAP** (Specifications for Non-Heat Advertising Printing). These specifications for newspaper and other non-heatset publications printed on uncoated papers were set up for color proofing and printing.

Years ago, the gravure industry converted to the halftone gravure process. They agreed that advertisement separation films produced for lithography should also be usable for making gravure cylinders. The Gravure Association of America established a set of *Group VI inks* that matched the hues of SWOP inks. The association also established methods for converting films for use on cylinder engraving machines. Now that ads are being done digitally, the file can be sent directly to the engraving machines, eliminating the need for the separation prints.

The SWOP, SNAP and Gravure specifications are continuously being refined and updated. You should contact each organization directly to obtain a set of the latest specifications.

**System Brunner**

Since 1973, Felix Brunner of Locarno, Switzerland has been refining his color control system. He and his research group have studied thousands of presses and developed a large data base. Brunner states that color control requires control of color fidelity, graduation and sharpness. Color can vary in lightness, saturation and hue.

The Supermicromeasuring Element is the hub of the System Brunner. It is equivalent to a 150 line screen and consists of a target of round dot sizes from 1/2 percent to 99 1/2 percent, 50 percent square dots, horizontal and vertical 50 percent parallel bars, and small negative and positive crosses. Any given area has an average dot size of 50 percent, and each pair of dots in the element has an average dot size of 50 percent. Since slur is a directional dot gain, the parallel bars are slur targets.

# REFERENCES

AAAA, American Association of Advertising Agencies, 666 Third Ave., New York, NY 10017-4056

ABP, American Business Press, 205 East 42nd St., New York, NY 10017-5706

Bann, David and John Gargan. *How to Check and Correct Color Proofs.* Cincinnati, OH: North Light Books, 1990.

BL Mega Inc., 1504 Grundy's Lane, Bristol, PA 19007; 215/781-2200

Bruno, Michael, editor. *Pocket Pal.* Memphis, TN (6400 Poplar Ave., 38197): International Paper, 1992.

FOGRA, U.S.A. Representative is GATF

GAA, Gravure Association of America, 1200-A Scottsville Rd., Rochester, NY 14624-5785; 716/436-2150

GATF, Graphic Arts Technical Foundation, 4615 Forbes Ave., Pittsburgh, PA 15213-3796; 412/621-6941

GCA, Graphic Communications Association, 100 Daingerfield Rd., Alexandria, VA 22314-2888; 703/519-8160

GTI Graphic Technology, Inc., 211 Dupont Avenue, Newburgh, NY 12550; 914/562-7066

IPA, International Prepress Association, 552 W. 167th St., South Holland, IL 60473-2796; 708/596-5110

MPA, Magazine Publishers Association, 919 Third Ave., New York, NY 10022-3876; 212/752-0055

Photography and Layout Reproduction, Q74, Eastman Kodak Co., Graphic Markets Division, 343 State St., Rochester, NY 14650-0001

RIT, T&E Center, Rochester Institute of Technology, Technical and Education Center, 66 Lomb Memorial Drive, Rochester N.Y. 14623-5604; 716/475-5000

SNAP, Specifications for Non-Heat Advertising Printing, Non-Heatset Web Unit, Printing Industries of America, 100 Daingerfield Rd., Alexandria, VA 22314-2888

Southworth, Miles F., Frank Cost, Donna K. Southworth and Patty Cost editors. *Ink on Paper*, 1995 to present, W. Caslon and Company, Livonia, NY 14487-9716; 716 346-2776.

Southworth, Miles F. and Donna K. Southworth. *Color Separation on the Desktop.* Livonia, NY: Graphic Arts Publishing Inc., 1993.

Southworth, Miles F. and Donna K. Southworth editors. *The Quality Control Scanner*, 1981 through 1994, Graphic Arts Publishing Co., Livonia, NY 14487-9716; 716/346-2776

Southworth, Miles F., Donna K. Southworth and others. *Quality and Productivity in the Graphic Arts.* Livonia, NY: Graphic Arts Publishing Inc., 1989.

Southworth, Miles, Thad McIlroy and Donna Southworth. *The Color Resource Complete Color Glossary.* Livonia, NY: Graphic Arts Publishing Inc., 1992.

SWOP, *Recommended Specifications for Web Offset Publications*, 1993. Available from AAAA, ABP, MPA and SWOP, Inc., 60 East 42nd St., Suite 721, New York, NY 10165-0721; 212/983-6042

System Brunner USA, Inc., 12 Harbor Lane, Rye, NY 10580-2213

The Tint File, Parkside Worldwide, 30 Pantbach Rd. Birchgrove, Cardiff, CF4 1UA, UK; 44 1222-612-980.

TRUMATCH™ Swatching System, 25 West 43rd Street, Suite 817, New York, NY 10036-7402; 212/302-9100

# GLOSSARY

**A0, A1, A2, A3, A4, A5, A6, A7 and A8** International Standards Organization (ISO) page size dimensions, based on portions of a square meter, that are used as international ad print guidelines. The length to breadth ratio is maintained through each division of the basic A0 size—see also B0, B1, B2, B3, B4, B5, B6, B7, B8, B9 and B10.

| Name | Size in inches | Size in millimeters |
|------|----------------|---------------------|
| A0 | 33.11 x 46.81 | 841 x 1189 |
| A1 | 23.39 x 33.11 | 594 x 841 |
| A2 | 16.54 x 23.39 | 420 x 594 |
| A3 | 11.69 x 16.54 | 297 x 420 |
| A4 | 8.27 x 11.69 | 210 x 297 |
| A5 | 5.83 x 8.27 | 148 x 210 |
| A6 | 4.13 x 5.83 | 105 x 148 |
| A7 | 2.91 x 4.13 | 74 x 105 |
| A8 | 2.05 x 2.91 | 52 x 74 |

**AAAA** Abbreviation for American Association of Advertising Agencies—referred to as "the four A's."

**ABP** American Business Press

**absorption** The ability of the substrate to soak up liquids or ink.

**achromatic** Having no color.

**achromatic color removal (ACR)** See GCR

**additive color primaries** The colors red, green and blue. When white light is broken down into its component parts, a rainbow (visible spectrum) is created. Dividing the rainbow into about equal

thirds results in red light, green light and blue light. By combining (adding) the three colors of light together, white light is created.

**additive color theory** The mixture of red, green and blue light, the primary colors of light, to produce white light. Red light, green light and blue light are each approximately ⅓ of the visible spectrum. Red and green light projected together produce yellow. Red and blue light produce magenta. Blue and green light produce cyan. Yellow, magenta and cyan are the subtractive color primaries.

**against the grain** The direction across the grain. Paper is used at right angles to its grain in a sheetfed press. Paper is less strong and more apt to change size against the grain.

**algorithm** A sequence of exact instructions that define a method to solve a particular problem. For example, algorithms are used to create a digital halftone screen—see also screen algorithms.

**analog scanner** A computer or other device that manipulates analog data as variable voltages. Some scanners utilize hard-wired electronic circuits to do analog color correction and tone reproduction; other scanners utilize digital data to do similar functions — see digital scanner.

**angle indicator** A gauge on a clear polyester film that is laid over a screen tint or contact screen to indicate the four common screen angles for process color separation screen positives.

**APA** American Photoplatemakers Association

**API** American Printing Industry

**application** Any software program, that applies a set of routines to handle a specific task. Microsoft Word and Aldus PageMaker are examples of applications.

**APR** Abbreviation for automatic picture replacement, a term used by Scitex to describe a feature in its desktop-to-prepress system for

replacing low-resolution viewfiles with high-resolution scanned images. APR functions much like OPI.

**area mask**  An outline mask that isolates a specific area of an image either by shape, color or tone value.

**B0, B1, B2, B3, B4, B5, B6, B7, B8, B9 and B10**  International Standards Organization (ISO) page size dimensions, based on portions of a square meter, that are used as international ad print guidelines — see A0, A1, A2, A3, A4, A5, A6, A7 and A8.

| Name | Size in inches | Size in millimeters |
|------|----------------|---------------------|
| B0 | 39.37 x 55.67 | 1000 x 1414 |
| B1 | 27.83 x 39.37 | 707 x 1000 |
| B2 | 19.68 x 27.83 | 500 x 707 |
| B3 | 13.90 x 19.68 | 353 x 500 |
| B4 | 9.84 x 13.90 | 250 x 353 |
| B5 | 6.93 x 9.84 | 176 x 250 |
| B6 | 4.92 x 6.93 | 125 x 176 |
| B7 | 3.46 x 4.92 | 88 x 125 |
| B8 | 2.44 x 3.46 | 62 x 88 |
| B9 | 1.73 x 2.44 | 44 x 62 |
| B10 | 1.22 x 1.73 | 31 x 44 |

**banding**  1. Perceptible steps in a computer-generated graduated tonal fill.  2. Smooth gradations of halftone dots interrupted by strips of greater than, or less than, desired density caused by irregular film motion within imagesetters or film recorders. The stripes of irregular density run perpendicular to the direction of travel. Contouring, rather than being directional, is an unwanted darkening of areas that follow image densities — see contouring.

**beam splitter**  An optical device to redirect a beam of light in two or more directions. A color scanner splits the input light into red, green and blue light beams and directs each to a photomultiplier tube. The output beam splitter separates the light into as many as ten beams, one to each modulator.

**benzidine yellow**  See yellow

**bitmap**  A series of individual dots or pixels that define graphics. On a color or black-and-white system, a bitmap defines a character or an image by turning each pixel on or off. Each pixel must be recorded for a full image. Paint programs use this format and are different than vector graphics, which define graphics by points.

**black**  1. The absence of all reflected light caused by printing an ink whose colorant gives no apparent hue.  2. One ink in four color process printing

**black printer**  The plate made during the prepress printing process that is used with the cyan, magenta and yellow printers to enhance the contrast and to emphasize the neutral tones and the detail in the final reproduction shadow areas — also called key— see full-scale black and skeleton black.

**blanket**  The rubber surfaced fabric clamped around the cylinder of an offset press to transfer the image from the plate to the paper.

**bleed**  Extending an image beyond the finished trim size so that the image runs right to the edge of the printed sheet after trimming and binding — see also full bleed.

**bleed through**  The printed image on the reverse side of the sheet, or on the sheet below, is visible through the paper.

**blistering**  The formation of small bubbles in the printing caused by trapped moisture under the dried ink.

**blue**  Describes the color of a clear sky.  1. A primary color of light. 2. A portion of the color spectrum aligned between green and violet. 3. In printing, a secondary color resulting from overprinting dots of cyan and magenta process color inks — see additive color primaries and additive color theory.

**brightness**  1. The amount of light being reflected from a surface. 2. In a printed reproduction, the lightness value regardless of the hue

or saturation. Brightness is affected by the reflectance of the paper. This is not called brilliance.

**buffer**  A computer memory area that is used for the temporary storage of data waiting to be processed.

**burn**  The plate exposure.

**calibrated RGB color space**  A set of video monitor specifications that define a red, green and blue phosphor set, a white point and the opto-electronic transfer function included in Adobe PostScript Level. White point is the lightest neutral white that the output device is capable of rendering in a way that preserves color appearance and visual contrast.

**capstan imagesetter**  See flatbed imagesetter

**carbon wedge**  A small transparent gray scale made on a strip of film. A carbon wedge increases in density from clear film to a maximum density. The minimum to maximum variation may be in incremental steps, or it may be continuous. The scale is made using a carbon dispersion coating that has very fine grain with low light scattering characteristics. This attribute makes the carbon wedge suitable for scanner calibration. A photographic step tablet will scatter light rays and is not as useful in the scanner specular optics.

**CCD**  Abbreviation for charged-coupled device, a very small light-sensitive photocell that is sensitized by giving it an electrical charge prior to exposure. CCDs have a broad range of uses in optical devices such as video cameras, photocopiers and scanners. CCDs sense the amount of light from an image during the scanning of an image. CCDs are extremely small; each is several thousands of an inch as compared to a photomultiplier tube, which is the size of a radio tube. This small size makes it possible to use CCDs in desktop scanners. CCDs often have difficulty distinguishing small color and tone differences in the dark shadow areas, and are generally considered inferior to photomultiplier tubes for use in scanners.

**CCD array**  A linear arrangement of charge-coupled devices (CCDs). In a scanner a straight row of charged-coupled devices, which may only be one inch long, scan and measure the light from as many as 1024 points.

**CD ROM**  Abbreviation for compact disc read-only memory, a storage media for information, such as utility and applications software, that can be accessed (read), but cannot be altered or written onto the disc. CD ROMs store up to 600 megabytes of material and are identical in appearance to audio compact discs. Musical CDs are CD ROMS with read-only data.

**CEPS**  Abbreviation for color electronic prepress system, a highend computer-based system that is used to color correct scanner images and assemble image elements into final pages. Although the configurations and peripherals making up a CEPS used for graphic arts applications may vary, each CEPS is used to accomplish what can be done manually with duplicate transparencies and emulsion stripping. CEPS should not to be confused with highend scanners that color separate but do not assemble pages. CEPS is sometimes used to refer to a color electronic publishing system.

**chalking**  A condition that allows the printed dry ink to be wiped off the printed sheet. Usually caused by improper ink drying.

**chrome**  A slang term referring to a color transparency that is used as the original copy. Chrome is incorrectly used as a short term for Cromalin.

**CIE color space**  A three-dimensional mapping system, such as CIELUV, that is used to locate or plot the three color attributes. A colorimeter is used to measure the X, Y and Z tristimulus values from which the three-dimensional systems are calculated. CIELAB, CIE L*a*b*, and CIELUV use L or L* to represent the lightness or darkness value, ± A, a* or U to represent the red-green attribute value and ± B, b* or V to represent the yellow-blue attribute value. These color spaces are similar to the Hunter L,a,b Color Solid System.

**cold color**  See cool color

**color**  The visual sensation of human response to seeing certain wavelengths of light. To see color, there must be a light source illuminating objects that absorb or reflect the light to the human eye. The color or colors seen depend on the quality of the light source, the object's light absorbability or reflectivity (the color of the object), and the sensitivity of the human eye.

**color analysis**  A photographic record of the detail and amount of colorant in the original picture. Three photographic records are made using a red, a green and a blue filter for the cyan, magenta and yellow printers.

**color balance**  Maintaining the ratio of cyan, magenta and yellow ink during printing. This will keep all color hues consistent and produce a picture with the desired color, one without an unwanted color cast or color bias.

**color cast**  An unwanted overall discoloration of an original copy, color proof or reproduction caused by an overabundance of one color pigment or light. Color casts result in bluish red, pinkish blue, etc. reproductions. The color cast can be digitally altered during or after scanning by using gamma correction.

**color chart**  A printed array of color patches that are used to choose, communicate and match colors. The color of each patch varies, one from another, and is made to given amounts of cyan, magenta, yellow and black inks or of premixed colors — see Focoltone, Pantone Matching System and TRUMATCH.

**color control bar**  A film test strip printed or exposed onto a film or substrate to produce an assortment of measurable color and gray patches that are used to measure and control the printing process and proofing.

**color correction**  A deliberate change of certain colors in the original when it is reproduced. The customer may have requested the

modification, or it may be needed because of the colorants that were used to reproduce the image. Inks for process color are not pure colors; each appears as though it is contaminated with the other two colors and has a hue error that requires compensation in the separation images. The changes can be made electronically, photographically or manually so that the separation films produce the desired result — see also retouching (digital).

**color gamut** The complete range of hues and strengths of colors that can be achieved with a given set of colorants such as cyan, magenta, yellow and black ink printed on a given paper and given printing press. Although it can represent strength, it usually represents hues.

**color guides** See color charts

**colorimeter** An instrument for measuring the tristimulus values of color with a precise and defined response that is similar to the human eye. A densitometer can measure color strength, but is not a reliable indicator of color hue. Densitometers measure through separation filters which do not match the human visual response.

**colorimetry** A science of color measurement.

**color matching system** 1. A color chart that has been printed or stored in an electronic system and is used to compare color samples — also called a color swatching system. 2. A computer-based process that can measure a color and formulate a new set of colorant amounts to reproduce the measured color. The system can be used to mix special color inks.

**color negative** A color photographic film that was made from an original scene and is used to make a color print or separation.

**color OK** See OK sheet

**color proof** A visual impression of the expected final reproduction produced on a substrate with inks, pigments or dyes, or on a video screen — see contract proof, DDCP, digital proof, off-press proof, press proof, prog and soft proof.

**color reference**  A standard set of process inks that were printed to standard densities or strengths on standard paper and are used for color control.

**color scanner**  An electronic device that is used to produce color separations from color original copy. Each type of color scanner, or its software, analyzes the original, inputs the data from the original copy, compresses the tones for contrast, saturation and brightness, color corrects to produce the correct color hue, adjusts for the gray balance of the printing inks, increases the sharpness and enhances the detail for better resolution, and stores the corrected information in the temporary buffer. The corrected information may be transferred to a page makeup system, or it may be output as halftone positives or negatives at the correct size — see drum scanner and flatbed scanner.

**color separation**  The process of making a separate electronic or photographic record of the amounts of each process color of cyan, magenta, yellow or black needed to reproduce an original copy. The record may be a photographic film made through the red, green and blue separation filters or a computer file. A set of four separations, cyan, magenta, yellow and black, are required to reproduce an original color image, since each of the four process colors must be represented. The separations may be made photographically using traditional methods or digitally using electronic scanners and computer programs. The original copy may be a transparency (slide), reflection photographic print, drawing, painting or printed reproduction.

**color sequence**  On a printing press or color proof, the order of applying the yellow, magenta, cyan and black inks to the substrate.

**color space**  A three-dimensional space or model into which the three attributes of a color can be represented, plotted or recorded. Although not always called by the names hue, value and chroma, these are the three color attributes represented — see CIE color space and Munsell color space.

**color temperature** The temperature in degrees Kelvin to which a black object would have to be heated to produce a certain color light. 2900K is representative of a tungsten lamp. 5000K is close to the temperature of direct sunlight and is considered the most critical attribute of standard viewing conditions for color evaluation.

**color transparency** See transparency

**Compact Color Test Strip, GATF** A color control strip with very small patches for press sheet control on a lithographic press for color reproduction. Will detect sharpening, dot gain, doubling or improper pigment loading of the process ink.

**connectivity** The ability to connect—establish communication. In electronic publishing, connectivity is used to describe a color system's ability to be connected to workstations, peripherals, storage and output devices so that an entire color page can be produced.

**continuous tone** See CT

**continuous wedge** A narrow strip of film with an orderly progression of gray densities, ranging from zero to maximum density, without definite steps.

**contouring** A tendency of pixels with similar values to clump together when output. The effect in a reproduction looks like spots of darker density or color. When it appears as streaks across the image, it is called banding.

**contract proof** A color proof that represents an agreement between the printer and the client regarding exactly how the printed product will appear.

**contrast** 1. The visual relationship of the original to its reproduction. 2. The visual tonal relationship between an original image and its reproduction. Each density in the original, from the highlight areas through the middletone areas to the shadow areas, will result in a corresponding reproduced density. A step tablet or gray scale is used to relate the changes in the densities. Big changes in the steps result

in a "contrasty" reproduction, while small changes result in a flat reproduction. This relationship is also called gradation. The Greek letter $\gamma$ (gamma) is used to represent a numerical value for contrast. It can be illustrated in several ways.

Contrast can be shown graphically by plotting the densities of an original on the x axis against the printed (reproduced) densities on the y axis. The slope of this plotted line represents the gamma. A perfect gamma of 1.0 is a 45° line that represents an exact reproduction of the original image. Any portion of the plotted curve with less than a 45° slope is said to be low contrast. Most often a color reproduction will have normal contrast in the highlights and middletones, and lower contrast in the shadows.

A gamma value is computed by either of two methods. A small triangle drawn on the straight line portion of the plotted gamma curve gives a value for x (run) and for y (rise). The $\gamma$ value is determined by dividing y by x.

Another method to calculate gamma is to divide the density range of the original ($DR_O$) into the density range of the reproduction ($DR_R$).

$$\gamma = \frac{\text{rise}}{\text{run}} \text{ or } \frac{DR_R}{DR_O}$$

**cool color**  A color that elicits a psychological response or impression of coolness — a hue in the range from violet through blue to green. A color reproduction is considered cool if the color balance or gray balance is adjusted to be slightly bluish rather than pinkish or gray.

**copy**  The original job material furnished for printing, comprised of paste-ups, transparencies, photographs and other graphics — also called originals, camera-ready art or camera-ready copy.

**C print**  A photographic print made on photographic paper that is sensitive to all colors of light. It is exposed from a color negative. (Not to be confused with a dye transfer print.)

**Cromalin**™ A type of single sheet color proof that is used for verifying the colors, checking register, obvious blemishes and size of images. Cromalin is a trademark of DuPont.

**crossover** Describes an illustration that covers parts of two facing pages in a book or magazine. It gets its name from the fact that it crosses over the binding edge. It is important that both parts of a color illustration line up on both pages when the book is assembled and that the colors match on both halves of the reproduction.

**CT** Abbreviation for continuous tone. 1. In the printing industry, continuous tone describes an assortment of tone values that range from minimum density to maximum density in any amount. A CT image, such as a 35mm transparency or a photograph, does not contain halftone dots. CT can also refer to a scanned or computer generated picture file before it has been screened, in other words, before the image has been broken down into dots for printing on a press. 2. CT refers to the digital system's bitmap file format of scanned original images. 3. In the Scitex system, CT is the file format in which continuous-tone scanned images are stored.

**cyan** 1. The subtractive primary color that appears blue-green and absorbs red light. 2. A blue-green ink that is used as one ink in the four-color printing process—sometimes referred to as "process blue."

**CYMK** Abbreviation for cyan, yellow, magenta and black process colors, or inks.

**DCS** Abbreviation for desktop color separation, a data file standard defined by Quark to assist in making color separations with desktop publishing systems. Using DCS five files are created. There are four color files, containing the cyan, magenta, yellow and black image data, and a composite color view file of the color image, containing a viewable low resolution version of the color image.

**DDCP** Abbreviation for direct digital color proof, a proof produced on a substrate directly from the digital data stored in a picture or page file in a CEPS or desktop computer. A peripheral device

utilizing a photographic exposure, dot matrix, electrophotographic thermal transfer or ink jet printer is used to produce the color proof without the need for halftone films. These proofs reduce the need for some of the traditional color proofing materials that are often used during the production cycle.

**degradé**  A colored halftone tint that gradually changes in strength and hue from one edge to the other. The tint may vary in hue in both directions depending on which process color tint value changes. A vignette is only one color that varies only in strength (brightness and lightness); one color appears to fade away. Degradés are sometimes called graded tints and are incorrectly called gradations.

**delta E**  Often written ΔE, a given amount of color change. Delta refers to the Greek letter Δ that is used to indicate changing characteristics. In colorimetry, it is common to use a scale to indicate the change in a color hue and strength. A reading can be taken by pushing a button on the colorimeter that automatically displays a computational value which represents the amount of color difference. Industry research has shown that many customers will accept a variation in their printed products of six ΔEs.

**densitometer**  An electronic, process control instrument that is used to measure the density (darkness) of visual images and colorants. Colored ink or dye densities are measured through their complimentary filter to indicate their relative strength. A densitometer should not be used to indicate a point in a three-dimensional color space model. Density measurements are used to calibrate color systems and to control color processes.

**density**  The visual darkness of a material caused by its capability to absorb or reflect the light illuminating the material. Density is measured with a densitometer. Colored materials are measured through their complimentary filters. Density differences are sometimes called gray levels. As density increases the amount of reflected or transmitted light is reduced. The amount of light absorbed is inversely

proportional to the amount of light reflected from or transmitted through the sample. Density is represented by the equation:

$$\text{Density} = \log_{10} \frac{1}{\text{Transmittance}} \text{ or } \log_{10} \frac{1}{\text{Reflectance}}$$

**density range**  Means the same as tonal range, the maximum range of tones in an original or reproduction, calculated as the mathematical difference between the maximum and minimum density (the darkest and the lightest tones). For example, a transparency might have a 3.0 shadow density and a 0.25 highlight density. The lowest tone value, 0.25 is subtracted from the highest tone value, 3.0; the result is a 2.75 density range. A printed density range is 2.0 maximum or less.

**desaturated color**  A color that appears faded, printed with too little ink, or as though white had been mixed with the colorant.

**desktop color**  The photomechanical reproduction of color accomplished by using a standard-platform tabletop computer that works with PostScript, such as a Macintosh, PC, NeXT or Sun workstation, linked with a desktop flatbed color input scanner and output peripherals, such as a direct digital color proofer, laser printer, and black-and-white imagesetter. The color image is scanned, viewed on the monitor, corrected, processed, stored, imported into a page makeup program, and output to a color proof and to halftone film. At the time of this writing, the color quality of desktop systems is not equal to the color quality of the highend CEPS. It is possible to improve desktop color quality by selecting input scanners, color proofing devices and imagesetters of higher resolution. Usually for the highest quality desktop color, picture files are imported from highend scanners — see also CEPS and midrange system.

**detail enhancement**  A scanning term, the technique of exaggerating picture image edges with the unsharp masking or peaking scanner

control, so that the observer can see all the detail of the original in the reproduction — see also unsharp masking (USM) and peaking.

**device-independent color**   A concept referring to color images that appear the same on different output devices, including monitors and various printers.

**diffuse highlight**   The whitest neutral area of an original or repro-duction that contains detail and will be reproduced with the smallest printable dot. Diffuse highlight should not to be confused with spec-ular highlight, which is a direct reflection of a light source in a shiny surface, has no detail, and is printed with no dot.

**digital camera**   An image-capture device that captures and records a single image on an integrated circuit card or a hard disk. The image may be stored in an analog or digital format.

**digital photography**   The process of capturing an original image with a camera that digitizes the image at some point in the process. This digital image may be displayed on a video monitor, manipu-lated and included in an electronically completed page.

**digital press**   A lithographic printing press designed to print from plates that have been digitally imaged either on or off the press using a data base. This allows for short pressruns of variable data with lit-tle or no makeready time.

**digital proof**   A black-and-white or color image reproduction made from digital information without producing intermediate films. A picture file, data file or text file can be represented by a digital hard proof made directly on a substrate using a peripheral output device, or displayed as a digital soft proof on a video monitor — see color proof and DDCP.

**digital scanner**   An image scanning device that determines a digital discrete gray level or density for each pixel area scanned. A digital color scanner uses the digital values with software to do the neces-sary color correction and gradation changes. An analog color scanner

uses analog voltages in hard wired circuits to make the needed color correction and gradation changes. Although digital scanners are preferred, there are many analog scanners being used.

**direct digital color proof** See DDCP

**direct-to-plate** Refers to digital imaging technology that allows composed pages to be output directly to printing plates rather than first to film.

**disc** This spelling of the word disk is usually used in reference to optical discs, rather than digital floppy disks.

**disk** A flat, circular information storage medium with a magnetic surface on which information can be recorded, as compared to a disc that is an optical storage media.

**Dmax** (DEE-max) Acronym for maximum density.

**Dmin** (DEE-min) Acronym for minimum density.

**dot** The individual element of a halftone. Dot should not be confused with spot, the smallest diameter of light that a scanner can detect, or an imagesetter or film plotter can expose — see also elliptical dot, pixel and screen ruling.

**dot area** The percentage of an area covered by a halftone dot ranging from no dot at 0% to a solid ink density at 100%. The size of the dots is stated in percentage of the area they occupy. A square dot at 50% creates a checkerboard pattern.

**dot etching** A technique that physically reduces dot sizes on film by emersion in acid, by using photographic overexposure on contact and dupe films, or by computer electronic etching or airbrushing. Dot etching is done to change hues in specific reproduction areas.

**dot gain** The apparent dot size increase from the film to the printed reproduction. Dot gain can be simulated on a video monitor by adjusting the white point and gamma (contrast).

Dot gain is the physical enlargement of the dot caused by plate exposure image spread, by the pressures between the plate blanket and impression cylinder of a press, or by ink spread as it penetrates the paper. The apparent darkening of the dot border can add as much as 20% to the dot gain. Since the dot gain is greatest where the dot circumference is largest, the dot gain profile usually appears as a Volkswagen curve when plotted. Choosing too fine a screen ruling will increase the dot gain and cause plugging on the press.

The dot diameter expansion is usually uniform in dots of different sizes, making the diameter of the dots change by the same amount in highlight, middletone or shadow dots. However, the area around the dot will increase more when there is greater circumference around the dot. Therefore, the greatest dot gain occurs in the middletone, around the 50% dot size. This tends to darken reproductions by printing too much middletone dot area. In process color printing, dot gain is usually greater in the unwanted colors causing a "dirtying" of all hues. To compensate for the middletone dot gain, the prepress should reduce the dot sizes throughout the middletones in all colors so that the separations fit the dot gain of the printing process. Some typical dot gains as measured with a dot area meter are as follows:

> coated sheetfed lithography at 150 lpi............. 15% dot gain
> uncoated sheetfed lithography at 133 lpi........ 20% dot gain
> coated web offset for SWOP at 133 lpi ............ 22% dot gain
> newsprint web offset at 100 lpi.......................... 30% dot gain

See also doubling, fill-in, optical dot gain, physical dot gain and slur.

**dot shape** The form of the halftone dot that may be intentionally varied from round to elliptical to square. Halftone dots are made with specific physical configurations to minimize dot gain and moiré. The dot shape is varied to minimize the dot gain at the point where dots join one another. Elliptical dots minimize the sudden dot gain where corners of dots connect; they may connect in their short direction at

40% dot area and in their long direction at 60% dot area. Round dots, often used for newsprint, may not connect until about 70% dot area.

**dot sharpening** The technique of reducing the printing dot sizes of halftone separation films to compensate for the expected dot gain on press. The reduction is done mostly with the middletone controls as that is where the gain is the greatest.

**doubling** A printing defect of lithographic printing caused by a mechanical problem on the press that results in a second set of dots printing between the desired set of dots in a halftone image. The defect appears as color changes and a darkening of the reproduction.

**drawing** Desktop publishing software that employs vector graphics, as opposed to a paint program that uses bitmap graphics.

**drop-out highlight** See specular highlight

**drum imagesetter** A high resolution laser output device that utilizes a revolving drum. The film is mounted on the drum (external drum imagesetter) or in the drum (internal drum imagesetter) for exposure, as compared to a roll-fed or flatbed imagesetter, where the film is pulled with rollers past a light source.

**drum scanner** An optical scanning device for converting an optical image to an electronic image by analyzing the original copy mounted on a revolving drum or cylinder. As the drum revolves a spot of light illuminates the surface while a photodetector looks at each pixel spot as it passes by. After each row of pixels is analyzed, digitized and stored, the optics move sideways one row and repeat the process until the entire picture raster image is stored. A color scanner utilizes a red, green and blue filter to analyze the pixels. Most highend scanners are drum scanners with photomechanical tubes that produce the high resolution images. Flatbed scanners usually utilize CCDs to analyze images, usually at lower resolutions than drum scanners.

**dry back** The change in ink density during drying. The ink density becomes lower from wet to dry, caused by the surface change from glossy to matte. Also called dry down.

**dry etching**  A technique for changing the dot sizes in all or specific areas of color separations by manipulating the contact printing exposures on photographic films.

**dye sublimation printer**  A digital proofing device that transfers dye images from a carrier sheet to a receiver sheet by placing the two sheets together during or after exposure.

**editorial changes**  Customer modifications requested to change certain elements within the original image during the separation process.

**Ektachrome**  A photographic color emulsion type film used to make color transparencies, manufactured by Eastman Kodak Co.

**electronic camera**  A camera that captures the image as analog data and records the information as either analog or digital data. Later the image can be displayed on a video monitor as a single frame that is shown over and over again.

**electronic still photography**  Photography that is either analog or digital, or both, but where the image is in an electronic format at some stage in the picture handling process.

**elliptical dot**  An elongated, or oval, halftone dot that is used in the middletone and vignette areas to minimize the midtone jump in dot gain at the point where dots are large enough to connect.

**emulsion**  The light-sensitive coating, made from photo-sensitive materials, that is used on photographic films or printing plates.

**emulsion side**  The dull-appearing surface of a photographic film on which the emulsion has been applied; the side on which the image is developed or scribed. The emulsion side of the film should be down against the plate coating during exposure so that image sizes are not unintentionally spread and made fatter.

**exposure**  The illumination amount and duration striking a sensitized material, such as film, paper or plate, or an electronic sensor, such as a CCD.

**exposure level**  The quantity of light that is allowed to act on a sensitized material, such as film, paper or plate, or an electronic sensor, such as a CCD.

**fan book**  In a color matching system, a set of small color charts, similar to a deck of cards that have been fastened together with a clasp in one corner. The user can spread the charts and match a sample to the correct color patch.

**fatties and skinnies**  A fatty is a spread, and a skinny is a choke — see spreads and chokes.

**fill-in**  One of several types of dot gain caused by reasons other than doubling or slur.

**film negative**  A photographic record of an image that is tonally reversed.

**film plotter**  In color systems, a stand-alone device that writes across film using a laser or LED to expose type, line or halftone images in a sequential manner. Film plotters are different from imagesetters and film recorders in that they have no raster image processor directly connected to them.

**film positive**  A photographic record of an image that is tonally correct.

**fingerprinting**  A method of testing a printing press to determine its exact printing characteristics, such as its dot gain, ink density and trapping, for the purpose of customizing color separations for those printing conditions.

**finishing**  Making final adjustments for slight color changes in a gravure cylinder. Done by manual techniques to change the depth of the cells on the cylinder.

**FIPP**  The European specifications for offset printing on coated paper; the International Federation of Publishers Press developed these guidelines for color proofing and printing of periodicals.

SWOP are the equivalent U.S. specifications; SNAP are the U.S. specifications for printing on newsprint.

**fit**  Maintaining the exact distances between images from the film to the printed substrate. Fit and register are not synonyms.

**flat**  1. A collection of properly imposed negatives or positives attached to a goldenrod or film carrier sheet from which the plate will be exposed.  2. Properly imposed pages that will result in a signature.  3. A term that is used to describe a photograph that is lacking in contrast.

**flatbed imagesetter**  An imagesetter that feeds the paper or film from a roll and holds it flat while it moves past the exposing light. Sometimes called roll-fed imagesetter or capstan imagesetter, because the paper feed mechanism uses capstan rollers. The alternative is a drum imagesetter.

**flatbed scanner**  A peripheral digital device that uses a flat glass surface on which the original is mounted and scanned. The light moves across the surface to create a digitized black-and-white or color separation file of any two-dimensional image, such as a transparency, photograph or artwork. Most flatbed scanners use CCD sensors — see also drum scanner.

**flexography**  A printing process that uses a raised surface, flexible rubber or photopolymer printing plate mounted on a rotary drum and thin, fast-drying inks to print on almost any material.

**Focoltone®**  A color matching product that utilizes an array of printed color swatches. Focoltone is used to specify process colors.

**foot candle**  A standard unit of illumination, the light given off by one lit candle measured at a distance of one foot. For example, the illumination level in a standard viewing booth is 200 foot candles.

**for position only (FPO)**  On a mechanical, a designation that an image has been added only to indicate its position within the layout.

The artwork or transparency to be reproduced in the same position is sent separately.

**FPO**  Abbreviation for "for position only."

**Fujichrome**  A photographic color emulsion type film manufactured by the Fuji Company and used to make color transparencies.

**full bleed**  A bleed extending into all four margins.

**full-scale black**  A black printer separation that contains picture elements ranging from the whitest highlight to the darkest shadow and prints dots in every part of the picture. Full-scale black, also called full-range black, differs from a skeleton black, or half-scale black, which only prints dots in the darker areas of a reproduction.

**GAA**  Abbreviation for the Gravure Association of America, an organization dedicated to the advancement and dissemination of information for the gravure industry.

**gamut mapping**  The process of aligning the color space of one device with that of another, accomplished with algorithms or look-up tables.

**GATF**  Abbreviation for the Graphic Arts Technical Foundation, an organization located in Pittsburgh, PA, dedicated to improving quality in the graphic arts through testing and education. GATF distributes a range of color quality control devices and publications.

**GATF Color Circle**  A circular plotting paper upon which the hue and gray of colors are plotted using readings taken with a densitometer. The GATF Color Circle is usually used for analyzing ink sets.

**GATF Color Hexagon**  A hexagon shaped plotting paper upon which the hue and strength of colors are plotted using readings taken with a densitometer. The GATF Color Hexagon is usually used to analyze the effects of printing process inks and their overprint colors, red, green and blue.

**GATF Color Triangle**  A triangular shaped plotting paper upon which the hue and gray of colors can be plotted using readings taken with a densitometer. The GATF Color Triangle is usually used for the purpose of determining masking for hue error correction.

**GCA**  Abbreviation for Graphic Communications Association, a subgroup of the Printing Industries of America. GCA is an organization of advertising people, color separators, publishers and printers dedicated to improving color publication printing.

**GCA/GATF Proof Comparator**  A set of four-color film test targets that are used to determine if a production proof is made correctly. These test targets are included each time a proof is made. The completed proof can be compared to a sample proof of the same color test target made under very exact, controlled standard conditions.

**GCA T-Ref**  See T-Ref

**GCR**  Abbreviation for gray component replacement, the technique of reducing the cyan, magenta, or yellow dot sizes that produce the gray component, or darkening effect, in a color without changing the hue of the color. The black dot sizes are increased to replace the gray component that has been reduced in the process colors. If 100 percent GCR were used, every color area in the reproduction might contain dots of only black and two of the three process color inks. Commonly used percentages are 50% to 75% GCR. The goal of GCR is more consistent color, increased detail in the shadows, shorter press makeready, and possible ink savings.

**glossy**  A shiny surface that reflects the specular component of light away from the eye and, therefore, appears more dense.

**gradation**  See contrast

**grain** (paper)  The direction of the fibers that corresponds to the direction the paper was made.

**graininess**  A transparency of a print appears grainy when the granular particles of the emulsion can be detected visually.

**gravure** An intaglio printing process that works with a cylinder in which the image is engraved below the surface. The ink is transferred when the paper is pressed in contact with the cylinder. Gravure is used for very long print runs. It can print on most any type of substrate.

**gray balance** Combinations of cyan, magenta and yellow colorants that appear similar to shades of gray. It is important to maintain the neutrality of the grays throughout the proofing and printing process.

**gray component replacement (GCR)** See GCR

**gray scale** A narrow strip of paper containing an orderly progression in definite steps or patches of gray densities or printed halftone steps ranging in dot sizes from zero to 100%. A gray scale is used to analyze and optimize the contrast of black-and-white and colored reproductions. The gray scale may be reflection-type made on photographic paper, on a color proof, or printed on paper. On film, with definite steps of either continuous tone or halftone dots, it is called a step tablet. On film without definite steps, it is a continuous wedge. On film with dots and definite steps, it is a halftone scale. On a computer monitor, shades of gray are created by varying the intensity of the screen's pixels, rather than by using a combination of only black-and-white pixels to produce shading. Printed, it is produced as a narrow strip of paper, usually in the trim area of a job, and used for analyzing printing characteristics.

**green** Describes the color of grass and lettuce. 1. A primary color of light. 2. The portion of the color spectrum that is aligned between blue and yellow. 3. In printing, a secondary color resulting from overprinting dots of cyan and yellow process color inks — see additive color primaries, and additive color theory.

**halftone** A negative or positive image made by photographing an image through a screen so that the detail of the image is reproduced with dots. The reproduction simulates the different tones of the

original by transforming them into dots of varying sizes arranged in a grid pattern that has a given frequency. For example, a 150 lines per inch (54 lines per centimeter) halftone would contain 150 rows and 150 columns of dots (22,500 in a square inch) that could vary in size from zero percent to 100 percent — also called screened negative or screened positive. Halftones can also be generated electronically from digital data.

**halftone screen** A screen with a grid pattern that is placed over the film during its exposure to produce the halftone dots of various sizes from the image of the original — see also screen algorithms.

**halftone screening algorithm** See screen algorithms

**halftone tint** An area printed with all the same dots to give an even tone or color.

**hand correction** Any manual technique to change colors of the reproduction by changing the dot sizes on the film, the printing plate, or cylinder.

**hard dot** A halftone dot on film that has well-defined edges with no fringe. Hard dots are exposed with a laser, or made by contact from another film. Dots made with a contact screen have soft edges that can cause dot sizes to vary during platemaking — see soft dot.

**hickey** a small void in the printed image caused by contamination in the ink or on the paper's surface.

**high-key transparency** A very light, possibly overexposed, transparency that has most of the important detail in the highlight area and has very few shadow areas. Contrast (gradation) must be adjusted differently for high-key transparencies than it is for normal or low-key transparencies.

**highlight** The most white portion of the original or reproduction that has no color cast. In the reproduction, it may print the smallest printing dot, the diffuse highlight, or print no dot, the specular highlight.

**high resolution file**  In a CEPS, the stored high resolution information that contains all the detail necessary to produce an accurately printed reproduction. Sometimes called high res file, it is commonly input at a sampling rate of at least four pixels for each dot to be reproduced at the final size. The corresponding low resolution file or viewfile is created at the resolution of the video monitor.

**holdout**  The ability of a paper to keep the ink on the surface. The ink gloss is directly related to the paper's ability to hold the ink on the surface. Too much holdout causes setoff.

**hue**  The attribute of color that designates its dominant wavelength and distinguishes it from other colors. Red is a different hue than green. While bright red and dark red may have a different brightness or lightness, they may be the same hue.

**hue error**  The amount of contamination in a process color pigment or ink that alters its appearance from that of a perfect process color. For example, because of yellow contamination, most magenta inks appear more red than a pure magenta ink, which is purplish red. All color separation software attempts to color correct for this error by reducing the dot sizes of the unwanted colors.

　　To analyze the hue error of an ink, you take three ink measurements with a wideband densitometer using the red filter, the green filter and the blue filter. The equation for calculating hue error is expressed as:

$$\text{hue error percent} = \frac{M - L}{H - L} \times 100$$

H is high density, M is middle density and L is low density

**imagesetter**  A high resolution laser output device, that writes, onto photosensitive paper or film, bitmap data generated by a RIP. Usually, typesetters connected to desktop publishing workstations are now called imagesetters because they can record halftones and

line images as well as type. There are two main types of imagesetters — flatbed and drum.

**ink-film thickness** A term implying the amount of ink that has been deposited on the substrate's surface.

**ink opacity** The ability of overprinted inks to prevent the color of the first printed ink from passing through. Process inks are transparent.

**in-line** Describes components of a system arranged in a logical production sequence. For example, an in-line film processor can be connected to an imagesetter so that the film is output directly from the imagesetter to the processor without operator intervention.

**in-line problem** An imbalance difficulty that occurs when the page printing above another in the direction of travel on a printing press requires a different ink feed. Example: the top page needs more magenta, while the page below needs less magenta. It is impossible to correct this situation on press; the halftone images must be altered.

**inter-instrument agreement** The ability to get exact concurrent data using different instruments, such as with densitometers.

**International Prepress Association** See IPA

**IPA** Abbreviation for the International Prepress Association, a non-profit professional trade association comprised primarily of color separators.

**IPA Standard Color References** Printed samples of SWOP inks used for controlling publication proofing and printing. The Hi-Lo Reference illustrates the high and low density for each ink. The Single Level Color Reference is printed at the optimal standard density.

**ISCC** Abbreviation for the Inter-Society Color Council, an organization of persons interested in color.

**K** 1. Abbreviation for kilo, which is 1000 units.  2. Abbreviation for kilobyte, a measure of data quantity, roughly 1000 bytes, which in

fact is 1024 bytes or $2^{10}$. 3. Abbreviation for Kelvin, which is also a unit of measurement of color temperature. 4. The "K" in CYMK stands for key or black printer.

**Kelvin** 1. The scale of absolute temperature in which the zero is approximately -273.1°C. 2. A unit of measurement in printing that is used to describe the color of a light source, such as 5000K standard viewing conditions. Kelvin is abbreviated as K.

**key** Another name for black printer. When letterpress was the popular printing method, black was printed first. The other colors were then registered visually to the black image, which was considered the key color. The "K" in CYMK stands for key.

**Kodachrome** A photographic color emulsion type film used to make color transparencies, manufactured by Eastman Kodak Co.

**letterpress** A method of printing from plates with raised images. There are four types of letterpress presses: platen, flatbed cylinder, rotary and belt.

**line copy** High contrast reflective artwork, with no shades of gray, preferably in black-and-white, although colors can be photographed with appropriate filters and film.

**lines per inch** (lpi) Number of input scans or output exposure lines in a linear inch. Halftone screens are rated in lines per inch, which represent rows of halftone dots per linear inch. For example, a 150-line screen would consist of 150 rows by 150 rows of halftone dots creating 22,500 dots in one square inch.

**lithography** A process that prints from flat plates using water to repel the ink from the nonimage areas of the plate. The images are first printed to a rubber blanket and then offset to paper, thus the popularity of the name "offset" or offset lithography.

**lithol rubin magenta** The reddish magenta pigment used to make an ink for process color printing. This magenta ink has a greater

hue error and is more reddish than the bluish rhodamine magenta process ink.

**low-key transparency** A dark, possibly under-exposed, transparency that contains most of the important detail in the shadow area.

**MAC** Abbreviation for Magazine Advertising Canadian Specifications, color separation and proofing specifications similar to SWOP.

**magenta** 1. The subtractive primary color that appears bluish red and absorbs green light. 2. One ink in the four-color printing process — sometimes referred to as "process red."

**main exposure** The image or detail exposure made through the contact screen to make a halftone negative by photographic methods.

**MARKOLOR**™ A patented graphic process of interpretive condensing of all graphic information from full color artwork through a series of filters or scans to two films, impulses or impressions. MARKOLOR separations are printed with two colors, usually red and green, red and black or red and blue. MARKOLOR separations can be printed on a wide range of materials using a wide range of printing processes.

**mask** A photographic film placed over an image in order to modify the light that will pass through the image, thereby changing a characteristic of the reproduction. This task can also be handled electronically on digital prepress systems. There are a variety of masks, including area masks, outline masks and unsharp masks — see unsharp masking (USM).

**masking equations** Mathematical expressions of the relationship between the amounts of ink printed and the resulting red, green and blue densities or reflectances. These equations are used in an attempt to correct for the hue errors of a given ink set.

**Matchprint**™ An off-press, single sheet color proof manufactured by 3M. Matchprint is comparable to Cromalin. Color-Key is a 3M overlay color proofing system.

**matte** A dull or rough surface, lacking gloss or luster, such that more light is reflected to the eye, and colors appears less dense.

**maximum density** The heaviest density achievable with a given imaging system or material. For example, in printing the maximum density might be 2.0 for coated paper, 1.6 for uncoated paper and 1.2 for newsprint — also called Dmax.

**mechanical** Complete pages, with text, line art and crop marks in position, ready to be photographed for reproduction — described as camera-ready art.

**melding** To blend together images from two or more originals into one reproduction.

**memory colors** Familiar colors that are regularly seen in common objects, such as blue sky, red apples, green grass and human flesh. Color separators should adjust the tone reproduction and color correction so that memory colors appear natural.

**metameric color** (meh-ta-MER-ic color) A color that changes its perceived hue under different illumination. For example, it is possible to have two color samples match under tungsten illumination and not match when viewed in sunlight.

**middletone** Tonal values of a picture, an original or a reproduction, midway between the highlight and shadow — also called midtone.

**midrange system** A page makeup system priced between lowend desktop systems and highend CEPS. Midrange refers to the cost of the equipment, rather than the equipment or its output quality. Midrange systems may or may not use PostScript, and may or may not use desktop computers. These systems, computer and software bundled with a scanner, proofing device and an output film recorder, are priced generally in the $250,000 range.

**midtone**  See middletone

**modeling**  The process of rendering shading details in a picture so that objects appear to be three dimensional, have surface texture or have relief, such as the ripple on an orange peel. The least predominant color usually produces the detail, but too much of the least predominant color will darken the overall image.

**moiré or moire**  An objectionable interference pattern caused by superimposing one regular pattern over another such as with halftones or screen tints. Moirés can be caused by misalignment, incorrect screen angles, slipping or slur. They can usually be minimized by placing one screen over the other screen at a 30 degree angle difference.

**MPA**  Magazine Publishers Association

**multiple internal reflections**  A phenomenon that causes the light striking the paper to be absorbed by the paper and not reflected. This causes an increase in the optical density and a tone value darker than would be predicted.

**Munsell color space**  A widely-used color system (with color chips) using hue, chroma and value. Munsell is based on human perception and the visual differences of the three color attributes.

**NAPIM**  National Association of Printing Ink Manufacturers

**negative**  1. A film that has the light and dark parts tonally reversed from those of the original copy.  2. The film image of a completed page that is used to make a negative working offset printing plate, which will produce a positive printed image.

**negative working plate**  A printing plate that is exposed through a film negative and used to print a positive image.

**neutral gray**  Any level of gray from white to black that has no apparent hue or color. A printed neutral gray may have the same appearance as one of the steps of a photographic gray scale.

**Newton rings** The objectionable, irregularly shaped, colored circles that are caused by the prismatic action of interfacing different smooth surfaces such as a piece of film in a contact frame or a transparency on a scanner cylinder.

**nonreproducible colors** Certain colors in nature and photography that cannot be reproduced using process inks. The color of the original is outside the color gamut that the inks can reproduce. For example, a very dark, deep, rich wine red.

**off color** Any color that differs from the standard or desired color.

**off-line** 1. (adjective) Describes a component or device that is used in conjunction with a system but is not connected to the system or network. An off-line device functions without tying up the network. For example, an off-line prescan analyzer is used to perform the prescan analysis function separate from the scanner prior to scanning. The information is input into the scanner by the operator using the manual controls or a floppy computer disk. 2. (adverb) For a component or device within a system or network, the state of not being currently connected.

**off-press proof** A color proof, which simulates the appearance of the printed reproduction, made without the aid of a printing press, using pigmented or dyed light-sensitive materials exposed with the film negatives or positives. An off-press proof may be an overlay proof or a single sheet proof and may be treated or not treated with post finishes to simulate the gloss of the printed reproduction—also called a prepress proof. Some common types of off-press proofs are NAPS, Color-Key (both overlay color proofs), Cromalin and Matchprint (single sheet color proofs).

**offset lithography** See lithography

**offset printing** See lithography

**OK sheet** A proof or a printed press sheet that is taken during press makeready or from the beginning of the pressrun, evaluated,

marked "OK," signed and used as a color quality control guide for the rest of the pressrun — also called pass sheet or color OK.

**on the fly**  Computer operation in real time. When there is no apparent delay in a computer function's execution, it takes place on the fly.

**opacity**  See ink opacity or paper opacity

**opaque (opaquing)**  1. (noun) Capable of blocking the transmission of all light—the opposite of transparent.  2. (verb) Blocking part of a film negative to avoid reproducing a flaw or unwanted image area. Opaquing is usually performed with opaquing fluid on a brush or with a special opaquing felt-tip marker.

**OPI**  Abbreviation for Open Prepress Interface, a communication connection developed by Aldus Corporation that facilitates links between CEPS and desktop publishing systems. Using OPI, view-files of full resolution scans can be transferred to desktop publishing systems and placed in page layout software. When the page file is sent back to the CEPS for processing and output, the high resolution image data is automatically swapped for the viewfile. OPI is now frequently used by any system that seeks to maintain high resolution image data separate from page layout files. OPI is often compared to DCS.

**optical dot gain**  When dots are printed on paper, some of the light that should reflect off the surface of the paper is trapped under the edge of the dot, increasing the density of the area. Rough textured papers or finer screen rulings will increase the darkening effect. System Brunner labels this the "Border Zone Theory."

**original**  Refers to the copy furnished by the customer for reproduction, such as artwork, transparency, reflection copy, painting, etc.

**outline mask**  The electronic silhouette created on a CEPS or color desktop publishing system to isolate a picture element from the rest of the picture content — see unsharp masking (USM).

**overprint**  To print dots of one process color ink over dots of another process color ink to produce overprint colors or secondary colors, such as red, green and blue.

**overprint colors**  Secondary colors, such as red, green and blue, that result from printing dots of one process color ink over dots of another process color ink.

**panchromatic**  A film sensitive to all colors of light. Panchromatic film is used to make photographic color separations from color originals. Electronic color scanners can use either orthochromatic or panchromatic sensitive films because the film is exposed by a laser.

**Pantone Matching System (PMS)**  Color charts that contain 747 preprinted color patches of specially blended inks, used to identify, display, and/or communicate specific colors. Both designers and printers utilize the system so that colors can be matched exactly. The Pantone Matching System remains the most popular color matching system for designers and publishers. Pantone also offers a Process Color System with 3,000 process color combinations. See also TRU-MATCH and Focoltone.

**paper opacity**  Paper's ability to keep the printed image on the reverse side, or on the sheet below, from showing through.

**pass sheet**  See OK sheet

**peaking**  1. A color scanner unsharp masking function that electronically adds two signals and increases the edge contrast of an image to be reproduced.  2. Electronic edge enhancement produced on the color separation negatives by exaggerating the density difference of image edges.

**percent dot area**  See dot area

**perfecting press**  A press that prints both sides of the paper at the same time as the paper passes through the press. All web and many sheetfed presses will perfect.

**photomultiplier tube**  This light sensitive device senses very low light levels by amplifying the signals applied to it during the sensing and gives drum scanners their superior color separation capabilities.

**phthalocyanine blue**  A pigment used for making transparent cyan ink.

**physical dot gain**  The increase in actual dot size from the halftone dot on film, or the dot in a computer file, to the same dot printed.

**picking**  The pulling of the paper surface off the sheet during the printing process. Picking occurs when the ink tack is greater than the paper surface's strength.

**pigments (ink)**  The material, usually granular, added to a vehicle or solvent to give ink its properties, such as color or opacity.

**pixel**  Acronym for picture element, the smallest picture sample that can be sensed, manipulated or output by a digital system. In a color system, each pixel is represented either by cyan, magenta, yellow and black values, or red, green and blue values.

**plate**  See printing plate

**plugging**  A small non-printing area between dots is filled with ink and prints as a solid. A type of dot gain.

**plus correction**  A printing value change that results in printing more after the modification.

**positive**  1. A film that has the light and dark parts tonally correct as compared to those of the original copy.  2. The film image of a completed page that is used to make a positive working offset printing plate, which will produce a positive printed image.

**positive printing**  A term that refers to the process of printing with positive working plates. The U.S. printing industry is traditionally negative based. Europe, on the other hand, is positive working. Positive working plates have a 5% dot loss that reduces the middle-tone dot size. This negative dot loss is an advantage for web-offset

printing because of the extra dot gain found on web-offset presses. When negative working plates are made, they have a 2% dot gain.

**positive working** The process of printing using positive separation films, flats of assembled film positives and positive printing plates, rather than negative separations and printing plates as used in negative working printing.

**positive working plate** A lithographic printing plate that is exposed through a film positive and used to print a positive image.

**prepress proof** See off-press proof

**press proof** An image printed before the production pressrun to verify that the desired effect can be achieved, using the production inks and production substrate. The press may or may not be the one used for the production pressrun.

**primary colors** The colorants of a system that are used to print the colors for the entire reproduction. Cyan, magenta and yellow are subtractive primary colors, while red, green and blue are additive primary colors.

**print contrast (PC)** A method that is used to measure and optimize the solid ink density, dot gain and shadow contrast, by adjusting the ink strength. During the pressrun, the solid ink density and the 70% tint density are measured. Print contrast is then calculated as follows:

$$PC = \frac{D_s - D_t}{D_s}$$

PC is print contrast, $D_s$ is the density of the solid, and $D_t$ is the density of the tint

**printing plate** An intermediate image carrier used on a printing press to transfer the image from the film or a digital file to the substrate — see negative working plate and positive working plate.

**process color** The statement, "The reproduction will be printed using process color," indicates that color separations will be made and printed using process color inks. When four separations are made, process color is also called four-color process — see also process colors.

**process color printing** A color reproduction made by overprinting halftone separations using process inks. Localized color of one process ink is called spot color.

**process colors** The printing ink colors, cyan, magenta, yellow and black.

**process inks** See process colors

**prog** An acronym for progressive proof, a series of color proofs that include the finished four-color proof, a three-color proof, each individual process color and two-color combinations of each process ink, which makes it possible to see each combination of colors separately. Progs are printed with ink-on-paper and used for press control when visually compared to the press sheet.

**progressive proof** See prog

**quality assurance** An organized program for the purpose of certifying an acceptable product — see quality control.

**quality control** A complete program of activities, such as customer service, process control, teamwork and sampling with inspection, designed to ensure that the customer is pleased with the final product. The goal is to produce a more than acceptable product the first time by removing the root causes of all process variability.

**quartertone** Picture tonal values produced with dot size percentages of approximately 25 percent dot area.

**random proof** A color proof consisting of many images ganged on one substrate, randomly positioned with no relation to the final page imposition. It is a cost effective way to verify the correctness of

completed scans prior to further stripping or color correction work — also called a scatter proof.

**Recommended Specifications for Web-Offset Publications**   See SWOP

**red**   Describes the color of apples and cherries. 1. The portion of the color spectrum between orange and russet (a reddish brown). 2. The portion of the visible spectrum with the longest wavelengths. 3. In printing, a secondary color resulting from overprinting dots of magenta and yellow process color inks — see additive color primaries and additive color theory.

**reflection copy**   Any opaque color artwork submitted for reproduction, as opposed to transparencies.

**reflection density**   The optical density of a reflection material as determined with a reflection densitometer.

**reflection print**   A photograph that reflects light from its surface.

**register**   Placing two or more images that will overprint in exact alignment, one over another, either on film or on a substrate. The normal acceptable registration variation is one row of dots.

**retouching (digital)**   The process of changing image appearance by altering individual pixels or groups of pixels using a variety of system tools, such as an airbrush or pixel clone. Retouching, which is utilized to correct flaws in an image or to make design changes, usually is done using full resolution video display.

**rhodamine magenta**   (ROAD-a-meen) The magenta pigment that is used to make magenta ink for process color printing. This magenta ink is nearly ideal as it appears as a bluish magenta. It is higher quality and more expensive than rubine magenta.

**RIP**   Abbreviation for raster image processor, a software program or computer that determines what value each pixel of a final output page bitmap should have based on commands from the page description language.

**ROP color**  Abbreviation for run of paper color. The process color is printed in the newspaper during the regular pressrun. Unlike colored inserts, ROP color is not preprinted for the edition.

**rosette pattern**  The minute circle of dots that is formed when two or more process color screens are overprinted at their appropriate angle, screen ruling and dot shape. A rosette pattern is desirable, where as a moiré is objectionable.

**rubine magenta**  (RUU-been) The reddish magenta pigment that is used to make a magenta ink for process color printing. This magenta ink has a greater hue error and is more reddish than the bluish rhodamine magenta process ink. It is less expensive than rhodamine ink and is used for magazine printing. Also called lithol rubine magenta.

**Rubylith**  A red acetate emulsion on a clear backing; a masking film that is used to make an opening. The film can be cut and stripped from the carrier.

**saturation**  The attribute of a color that describes its degree of strength and its departure from a gray with the same lightness.

**scanner**  An input device for analyzing and digitizing the content of an original.

**scatter proof**  See random proof

**screen**  1. In a process camera, a sheet of film with dot patterns that is placed over the film to be exposed to break the image into halftone dots. In digital systems stored gray levels are converted into dots using screen algorithms on output.  2. The electronic display surface of a video monitor or CRT.

**screen angle**  The position of the rows of halftone dots relative to degrees of a circle. When outputting the four films for reproduction, the dots of each process color are placed at a distinct and different angle, one to another. Usually, the major strong colors of cyan,

magenta and black are placed at a distance of 30 degrees between colors, although some software generates other screen angles.

**screening algorithms** Software that converts pixels which are stored as levels of gray into halftone dots of specific size, shape and screen angle for each process color. There are a variety of screen algorithms available in digital systems; many are patented.

**screen ruling** The number of rows and columns of dots per inch of a halftone screen. A 150-line screen, commonly used for offset lithography on coated paper, has 150 rows of dots by 150 rows of dots or 22,500 dots per square inch. The more rows of dots per inch, the less apt the observer of the reproduction is to notice the screen — also called screen frequency.

**screen tint** A halftone that contains an overall, uniform dot size.

**scumming** A printing defect that causes toning on the reproduction. From the cylinder or plate, a small ink amount is deposited in non-printing areas on the press sheet.

**secondary colors** See overprint colors

**sensitivity guide** A step tablet used to indicated when a plate or color proof has been properly exposed and developed.

**setoff** A printing defect that results in the wet ink rubbing off or marking the next press sheet.

**shadow** The darkest part of an image, usually with a density at or near maximum density.

**sharpen** To make halftone printing dots smaller. Using negative separations, sharpening is accomplished with dot etching. Over exposure will also sharpen the negative films. When positive working plates are made using positive transparencies, sharpening happens automatically and the size of the printing dots are reduced by 5%. This sharpening is called negative dot gain.

**sheetfed press** A printing press that feeds sheets of paper, rather than a continuous paper roll or web.

**single sheet color proof** A proof made by placing layers of toners, dyes or pigments on a single substrate without the intermediate thin membrane carrier sheets as used for an overlay color proof. Some common types of single sheet off-press proofs are Color-Art, Cromalin, Matchprint, Pressmatch and Signature.

**skeleton black** A black separation that adds detail and contrast only in the darkest areas of a four-color reproduction from the quartertones to the shadows.

**skinnies** See fatties and skinnies

**slur** The smearing of the halftone dots on the press sheet in the direction of travel through a lithographic press. This makes the dots look like comets and causes dot gain.

**SNAP** (snap) An acronym for the Specifications for Non-Heat Advertising Printing, a set of production specifications developed for uncoated and newsprint paper for separations, proofing and printing in the United States — see SWOP, MAC and FIPP.

**soft dot** A halftone dot with a weak fringe density surrounding a solid core. A dot formed using a contact screen will have dot fringe. The fringe will not hold back light during plate exposure, which results in an improperly sized dot — see hard dot.

**soft proof** A color video display that simulates the expected visual printed result of stored pixel data. Predictions about the appearance of the printed image can be made based on the image on the screen.

**solid ink density** The optical reflection density of an ink printing 100 percent dot area for letterpress or lithography or 100 percent strength for gravure.

**spectrum** The range of colors visible when white light is passed through a prism. The prism divides the white light into wavelengths from short to long.

**specular highlight** A direct reflection of a light source in a shiny surface that has no detail and is printed with no dot. Not to be confused with diffuse highlight, the whitest neutral area of an original or reproduction that contains detail and will be reproduced with the smallest printable dot. Specular highlight is also called drop-out highlight.

**spot color** Localized color assigned to a graphic or block of text, prepared with a color break and printed without the use of color separations. Usually process color is not assigned to the spot color areas. Spot color is frequently printed with nonprocess color inks, although process inks can be used as well.

**spreads and chokes** Spreads and chokes refers to a prepress function that compensates for printing press misregistration. A choke is the slight size reduction of the opening within an image into which another image will print; a spread is the slight size increase of the inserted image. Making the opening smaller and the inserted image larger causes the filling image to slightly overlap the opening's edges and prevents a white edge at the junction of the two images that might be apparent after printing — also called fatties and skinnies. Chokes and spreads produce image trapping.

**Standard Color References, IPA** See IPA Standard Color References

**Standard Offset Color Bar, GATF** A color control guide that is printed on the edge of a press sheet, consisting of assorted solids, tints, overprints, slur and sharpness guides, and used in offset lithography to control proofing and printing.

**standard viewing conditions** The requirements for the environment that were established by the ANSI Committee for evaluating transparencies or reflection prints. Simply stated: standard viewing conditions are comprised of a neutral gray surround, illumination by a light source of 5000K, and a light level of approximately 200 foot candles. Large format transparencies should be encircled by a 2-4 inch white surround and should not be viewed with a dark surround.

**step tablet** A narrow strip of film consisting of an orderly variable progression of increasing differences of neutral gray densities ranging from clear film to maximum density — also called a step wedge. Step tablets are used to control plate exposures — see also gray scale.

**step wedge** See step tablet

**strength** 1. The amount of colorant, dye or ink placed on a substrate. 2. The amount of pigment in the ink. 3. The paper toughness and ability to resist the pull of the ink and blanket.

**stripping** The process of assembling and arranging all of the film intermediates on a goldenrod or polyester carrier in their correct page position and imposition so that printing plates can be made. In electronic stripping, the page elements are appropriately positioned on the digital page layout.

**substrate** Any material that can be printed on, such as paper, film, plastic, fabric, cellophane or steel.

**subtractive color primaries** The process ink colors, cyan, magenta and yellow. Each absorbs or subtracts its complimentary color, red, green or blue, from the light reflecting off the paper. Cyan, magenta and yellow printed together produce a three-color black which is slightly brownish because of the unwanted hue error of the inks.

**subtractive color theory** The principle surrounding the printing of cyan, magenta and yellow inks on paper for the purpose of absorbing portions of the red, green and blue light that is illuminating the surface, to prevent it from reflecting back to the observer's eye. Different combinations of cyan, magenta and yellow are what create the appearance of the visible spectrum on the paper.

**swatch book** Color patches of many combinations of process colors or special ink colors that are printed on paper, bound into a book and used to identify or specify a given color. See also color matching system.

**swatching out** An evaluation technique that is used mainly in gravure printing to verify that the films and proofs furnished will in fact produce the expected results for a given printing system. The color proofs are compared to swatches with values of density and dot area already known to be achievable with the printing system.

**SWOP** Abbreviation for the Recommended Specifications for Web-Offset Publications, a set of specifications for color separation films and color proofing that is used to insure consistency of color printed appearance between different publications. The SWOP standard concentrates on evaluating the accuracy of the color proof and the ability of the printer (a person) to match the proof. SWOP was developed in the United States for magazine production as the result of a joint committee of the American Association of Advertising Agencies (AAAA), American Business Press (ABP), American Photoplatemakers Association (APA), Graphic Arts Technical Foundation (GATF), Magazine Publishers Association (MPA), National Association of Printing Ink Manufacturers (NAPIM) and International Prepress Association (IPA). Available from AAAA, ABP and MPA — see MAC, FIPP and SNAP.

**System Brunner** A color control method developed by Felix Brunner for the purpose of color optimization, as well as proofing and printing control, focusing on the influence and control of dot gain.

**tack** The amount of stickiness in printing inks that makes them print while minimizing dot gain.

**texture** The character of the paper surface or the modeling of the picture.

**three-color black** A neutral gray made up of cyan, magenta and yellow pigments in correct percentages and ink densities. However, by overprinting the process color inks in equal dot sizes, it appears brown, rather than gray, because of the ink impurities.

**three-color process** Without a black printer, three process colors are printed to produce a colored reproduction.

**three-quartertone** A picture tonal value produced with dot size percentage of approximately 75 percent dot area.

**TIFF** An acronym for Tag Image File Format, a standard file format that was developed by Aldus Corporation for bitmap or raster graphics, usually for scanned images. TIFF can handle a variety of image data, from 8-bit black-and-white images, to 24-bit color RGB or CYMK images. Vector graphics are usually stored in PICT or EPS format.

**tint** 1. A halftone of a specified dot percentage, less than 100%. 2. A variant of a color that is created by mixing a defined amount of white with the basic color. 3. Flat tints and spot colors are often called tints.

**tone** The character of a color, its quality or lightness. Used as a verb, to tone, means to change or modify a color.

**tone compression** The reduction of an original's tonal range to a tonal range achievable through the reproduction process.

**tone reproduction** The tonal relationships between all of the elements of a reproduction, the intermediate films and the original. A graphic analysis can be plotted to study the contrast of the reproduction. A four-quadrant plot showing all the tonal values is called a Jones Diagram. Tone reproduction, gamma, contrast and gradation may mean almost the same thing depending with whom you are talking.

**tone scale** A gray scale or step tablet used to evaluate the tone reproduction or contrast of a reproduction.

**toning** A printing defect that is caused by ink printing where it should not print. Toning is the weak color in nonimage areas of the reproduction that gives the visual appearance of more color everywhere.

**total printing dot** The total amount of printing dot in a given area on a press sheet or on halftone separation films.

**transparency** The photographic color positive film that represents a color image, such as Kodachrome, Ektachrome or Fuji Chrome — also called by the slang terms, tranny and chrome. Standard sizes are 35mm, 2 1/4″ x 2 1/2″, 4″ x 5″ or 8″ x 10″. Transparencies are the preferred original for color scanning because film offers higher resolution than photographic print material.

**trapping** 1. Adjoining colors overlapped by a row or two of halftone dots to minimize the effect of misregister. Without trapping a fine white line would appear between two color images during the printing of process color. 2. The ability of an ink to print onto another ink. One hundred percent trapping occurs when the same amount of ink will print on the first ink as on the unprinted substrate. More frequently undertrapping occurs, because one wet ink will not adhere properly when applied to another wet layer of ink. Ink trapping is controlled by adjusting tack.

**T-Ref** A Graphic Communications Association (GCA) standard reflection densitometer color reference that is used to calibrate a Status "T" densitometer. The T-Ref is made by printing SWOP inks onto paper at the appropriate densities. The T-Ref is calibrated with the use of a spectrophotometer. Accurately using the T-Ref calibration plaque improves inter-instrument agreement of densitometers.

**TRUMATCH**™ A color matching system that utilizes an array of printed process color tint swatches. TRUMATCH is used to specify process color tint values.

**UCA** See undercolor addition

**UCR** Abbreviation for undercolor removal. The technique of reducing the cyan, magenta and yellow content in neutral gray shadow areas of a reproduction and replacing them with black ink so that the reproduction will appear normal but will use less process color ink.

**undercolor addition (UCA)** A technique that is used to add cyan, magenta and yellow printing dots in dark neutral areas of the reproduction.

**undercolor removal**  See UCR

**undercorrection**  Insufficient color correction made to compensate for the hue errors of process inks. The result is a reproduction that appears to have one or all hues contaminated with the wrong color. The reproduction will print too dark; the colors will appear too warm or dirty. Undercorrection is the opposite of overcorrection.

**unsharp mask**  A fuzzy, low contrast photographic negative that is made from a transparency and placed over the transparency when separation negatives are exposed. The mask alters the light exposing the separations to color correct for the hue errors of the inks. Being unsharp, the mask also exaggerates (enhances) the edges of images, producing more detail.

**unsharp masking (USM)**  An edge enhancement process accomplished with one of three techniques, one photographic method and two electronic methods, optical and digital. Regardless of the method used, the result of USM is the same—all edges in the image are exaggerated, which produces more detail in the reproduction.

The photographic unsharp masking method uses an unsharp mask that also compresses the tones and color corrects.

Optical unsharp masking is done on a scanner by determining where edges occur. The original is analyzed through separation filters and through both the small signal aperture and the large USM aperture. The two signals are compared to produce a peaking signal that generates the enhanced edges.

Digital unsharp masking is done after the scanning has been completed. Adjoining pixel values of digitally stored images are evaluated to locate the edges. When an edge is detected, the software exaggerates the edges

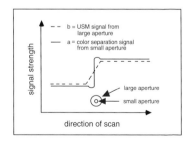

*Fig. 52  Unsharp masking signals*

by altering the value in the two adjoining pixels in opposite directions, thereby increasing the edge contrast. Unlike photographic USM, electronic USM does not color correct or compress the tones — see area mask, outline mask and unsharp mask.

**unwanted colors** Process colors that should not be present in certain areas of a reproduction, such as cyan in yellows or magenta in greens.

**unwanted densities** Optical densities, read with a densitometer, which indicate that a color will print more than it should or will print in an unwanted area.

**USM** See unsharp masking (USM)

**vehicle (ink)** The solvent of an ink into which a pigment is added.

**viewfile** A subsample, low resolution file of a digital image high resolution file usually created so that page layout software can operate more efficiently while still maintaining a viewable image. Often viewfiles are created at the computer monitor's resolution.

**vignette** A gradation change of only one color that varies only in strength (brightness) or lightness. In some cases, a vignette is created at the edge of an existing image, causing the color to fade to white over a specified area. Vignette does not change in hue while degradé changes in strength and hue.

**viscosity** The ability of a printing ink to flow at a certain rate, or the ink's fluidity.

**visible spectrum** Light that is visible to the human eye and is perceived as different colors. The visible spectrum is the 400 to 700 nanometer portion of the electromagnetic spectrum, which is the entire range of wavelengths from gamma rays to the longest radio waves. Infrared wavelengths are longer, and ultraviolet wavelengths are shorter than the visible spectrum—see white light.

**wanted color** A color that is supposed to print in a given area, such as magenta in red or yellow in green.

**warm color** A color that appears reddish or yellowish.

**web offset** A printing lithographic process that prints on paper from a continuous roll and delivers onto a roll or as folded signatures.

**web press** A printing press that prints on paper from a continuous roll and delivers onto another roll or as folded signatures. Lithographic, gravure, flexographic and letterpress printing processes can all use web presses.

**white light** Illumination, such as sunlight, composed of all the colors of light in the visible spectrum. The visible spectrum components can be seen in a rainbow or in sunlight shining through a prism.

**WYSIMOLWYG** An acronym for "what you see is more-or-less what you get." In most digital publishing systems, what you see on the monitor is rarely exactly what you get on output, and several observers felt that WYSIWYG was an overstatement of the precision of desktop publishing.

**WYSINWYG** An acronym for "what you see is not what you get," a play on WYSIWYG.

**WYSIWYG** An acronym for "what you see is what you get." The term is used in several situations, such as when a color proof is shown to the customer. The person presenting the proof assures the customer that what you see is what the press will produce. Or, in desktop publishing, the term is used to refer to the ability of desktop computers to display on their monitors a reasonable representation of what will appear on the printed page.

**yellow** 1. The subtractive primary color that appears yellow and absorbs blue light. 2. One of the four-color process inks, made from the organic pigment, diarylide yellow, formerly called benzidine yellow.

## ABOUT THE AUTHORS

Miles Southworth is a leading color printing technology authority. He is the Roger K. Fawcett Distinguished Professor of Publication Color Management at the Rochester Institute of Technology (RIT), School of Printing Management and Sciences (SPMS). Southworth is the author of numerous articles and books (see the list of additional books on page viii). He is past president of the Technical Association of the Graphic Arts (TAGA) and currently serves as secretary and treasurer. From 1981 through 1994, Miles and Donna Southworth have published *The Quality Control Scanner*, a monthly newsletter on color reproduction and quality control. Since January 1995, Miles and Donna Southworth have joined forces with Frank and Patty Cost to publish *Ink on Paper*, a monthly newsletter that deals with all forms of imaging, from technology and workflow to business planning.

Donna Southworth is vice president, secretary and treasurer of Graphic Arts Publishing Inc. She manages most functional areas of the publishing business. Working closely with Miles Southworth, she is actively involved in writing, editing and publishing literature for the graphic arts industry.